SEATTLE ART MUSEUM
BRIDGING
CULTURES

MAP & GUIDE

SCALA

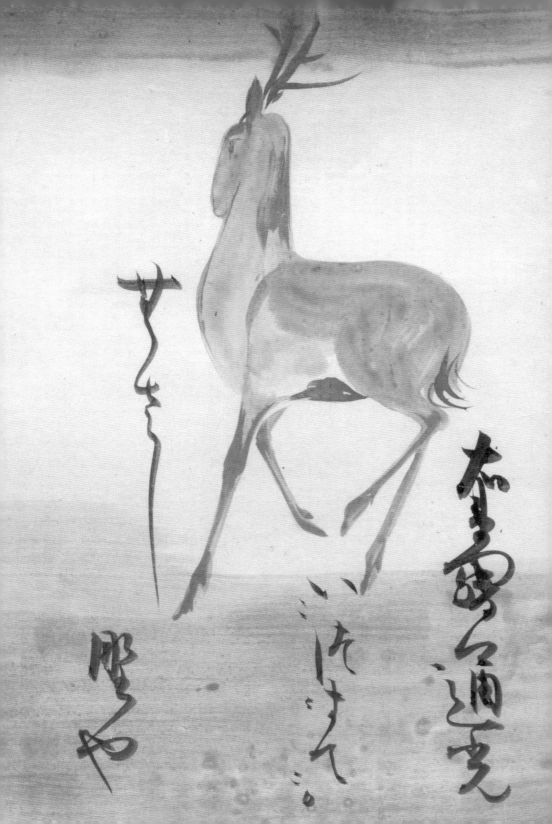

CONTENTS

FOREWORD

At the heart of a dynamic city which boasts a magnificent setting of lakes and mountains, the Seattle Art Museum (SAM) is the major visual arts institution in the Northwestern United States. Passionate collectors and curators, past and present, determine the distinctive shape of SAM's collections, ensuring that the museum embodies artistic excellence and features world cultures. Today our members are more committed than ever in helping us honor the museum's origins as we forge an exciting future together.

In the early 1930s, Dr. Richard Fuller, geologist, philanthropist, and ardent collector of Asian art, together with his mother Margaret Fuller, founded the museum when he made a gift of more than $250,000 to the city to build an art museum, the superb art deco building designed by architect Carl Gould and located in Volunteer Park. As its primary benefactor and director for the first forty years, from 1933 to 1973, Dr. Fuller established the collections' depth in East Asian art, American Art Deco, and classic Northwest artists, including Morris Graves and Mark Tobey. Subsequent directors, trustees, volunteers, and staff built on this strong foundation.

Sherman Lee, associate director 1948–1952, motivated the Samuel H. Kress Foundation to give high quality European art; and Virginia and Bagley Wright, together with Anne and Sidney Gerber, were in the courageous vanguard that sparked contemporary art. SAM's singular strengths in Northwest Coast Native American art and African art are the result of personal bequests of John Hauberg and Katherine White, respectively, with additional support from the Boeing Company.

Building on this legacy, SAM's collections are growing at an astounding pace thanks to the vision and generosity of major collectors. In 2001, under the inspired leadership of Board Chairman Jon Shirley and President Susan Brotman, SAM entered into an innovative partnership with Washington Mutual Bank to develop the remainder of our city block. This partnership enables both the museum and its flourishing collections to expand incrementally, eventually occupying 450,000 square feet of space, benefiting future generations of Seattleites.

We are pleased to welcome you to the Seattle Art Museum, one museum in three locations: the 1933 Seattle Asian Art Museum, the 2006 Olympic Sculpture Park, and the 2007 expanded SAM downtown. This guide will introduce you to a choice selection of works from all three of our sites, where extraordinary art experiences await you. Enjoy your visit.

Mimi Gardner Gates
The Illsley Ball Nordstrom Director

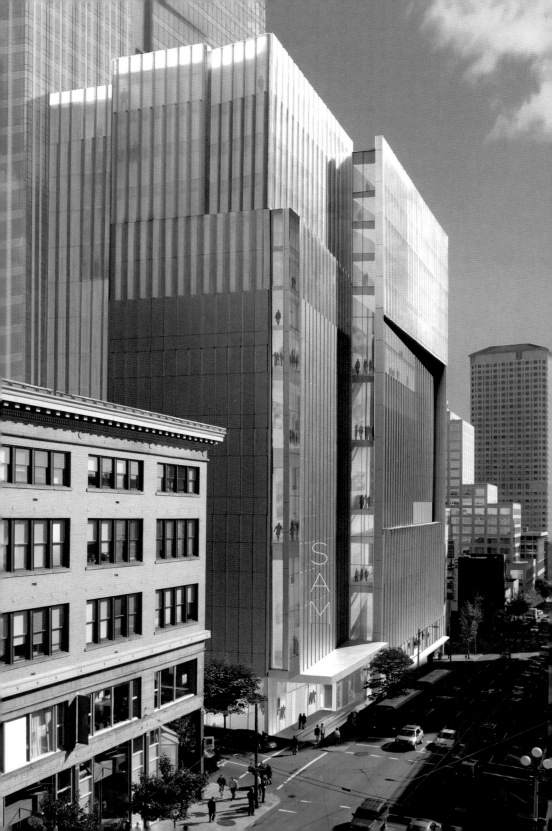

BRIDGING CULTURES AT THE SEATTLE ART MUSEUM

When the Seattle Art Museum, designed by architects Robert Venturi and Denise Scott Brown, opened in 1991, African, Native American, Meso-American, Ancient Mediterranean, Islamic, European, Oceanic, Asian, American, and modern art were installed in a sequence of galleries on two floors, in the belief that close proximity of art from different cultures would yield provocative and unexpected juxtapositions. Over time, it became clear that for the exhibits to maximize the impact of these visual surprises, the cultural intersections must be elucidated—a lesson that was essential in planning the new installation of collections for the museum's expansion opening in 2007.

The curatorial team developed a fresh strategy to display our global collection in new Allied Works-designed galleries and reconfigured spaces from the 1991 building. Mindful of SAM's vision statement "We connect art to life," works were selected for their meaning as well as their beauty and innovation. Presenting great art within large cultural groupings, stressing their original function and the artist's intent, would tie the diverse collections together. At the same time, we chose to create bridges between cultures and time periods through strategic adjacencies, highlighting points of commonality or counterpoints among works of art that arise from a complex and rich history of cultural interaction. These conscious juxtapositions invite visitors to see works from shifting vantage points in a way that we hope will be thought-provoking and enlightening.

This guide, a small sampling of the works on view—organized in the order in which they are displayed in the galleries—illustrates the exciting ways we have found to build on our initial concepts, presented as an invitation to come and see, explore, and discover the transformed and expanded collection for yourself.

Chiyo Ishikawa
Deputy Director of Art
Curator of European Painting and Sculpture

INTO THE FUTURE

One of the most significant international artists to emerge from China, Cai Guo-Qiang initially studied stage design at the Shanghai Drama Institute from 1981–1985. While living in Japan from 1986–1995, he adopted gunpowder as a medium for making spontaneous drawings, ultimately creating complex explosions on a massive scale at sites around the world. With *Inopportune: Stage One* he interprets explosions in a sculptural form, outfitting nine white Ford Taurus cars with festive, pulsing light rods.

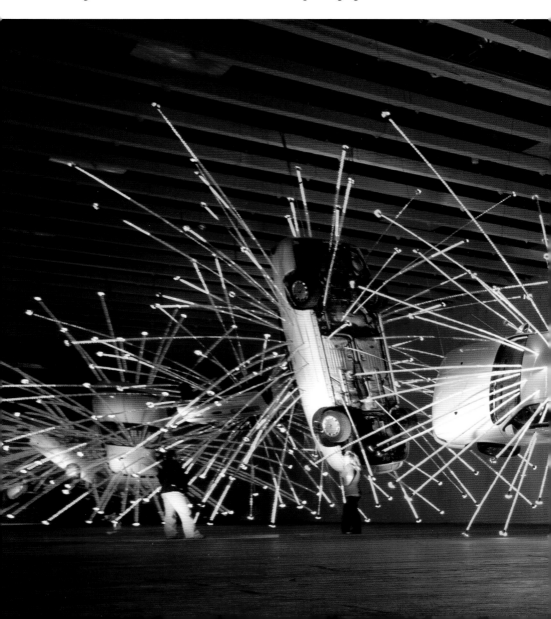

Suspended from the ceiling in a rising and falling arc, the sequence reads like a stop-action film; the composition begins and ends with a car on the ground, suggesting a continuous cinematic loop. Conceived in the wake of the September 11 tragedy, *Inopportune: Stage One* presents a compelling illusion of actions and events, inspiring reflection on the ambiguous role of images in our unsettled world.

Inopportune: Stage One, 2004, Cai Guo-Qiang, Chinese (works in America), born 1957, nine cars and sequenced multi-channel light tubes, dimensions vary

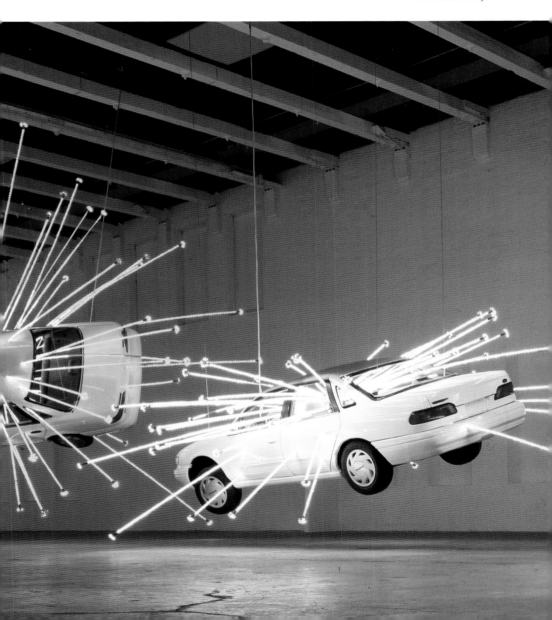

THE ABSTRACT OPTION

In 1920 Arshile Gorky left his native Armenia for America following the loss of his mother amidst the devastating confrontation of Turkey and Armenia. Known for abstract paintings rich with personal significance and influenced by landscapes both observed and remembered, in this work Gorky reveals his early response to surrealist ideas of drawing as a means to capture flights of the unconscious mind. The delicate, linear structure of *How My Mother's Embroidered Apron Unfolds in My Life* creates an abstract armature for a composition filled with nostalgia, but only loosely recalls the apron of his boyhood memory.

In the wake of World War II, Mark Rothko stripped painting of the figure, landscape, and narrative, liberating it to express elemental truths. His signature format from 1949 to the end of his life was a luminous composition of rectangular shapes floating in fields of vivid, atmospheric color. Rothko's techniques for generating a sense of inner light and dynamic space in his paintings were achieved by applying feathery-edged brushstrokes to a surface saturated with pigment. Through scale, composition, and an absence of imagery, he intensifies a viewer's encounter with the painting's physical and metaphysical presence.

(opposite)
#10, 1952, Mark Rothko, American, 1903–1970, oil on canvas, 81¾ × 42½ × 2¼ in.

How My Mother's Embroidered Apron Unfolds in My Life, 1944, Arshile Gorky, American, born in Armenia, 1905–1948, oil on canvas, 40 × 45¹⁄₁₆ in.

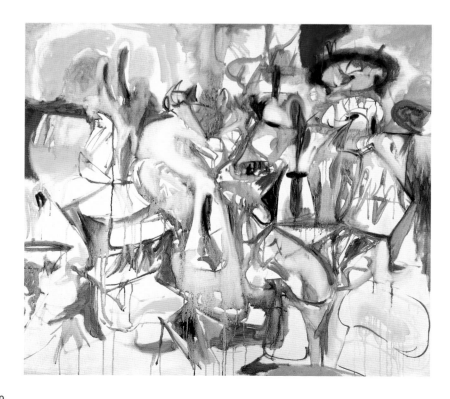

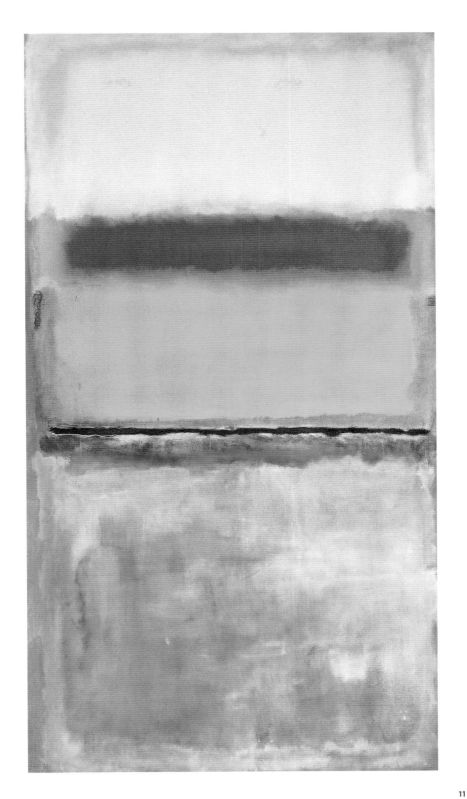

THE MEDIUM IS THE MESSAGE

Jasper Johns' *Thermometer* contrasts bravura brushstrokes with a metal-and-mercury object bought at a hardware store. In this construction, gestural painting—identified with intuition and emotion—is not spontaneous, but is instead a device under control of the detached artist. On the canvas, numbers painted adjacent to the thermometer are not a reliable form of measurement but a visual corollary to the disjunction between a symbol and an intangible quantity or quality. When Johns painted *Thermometer* he had recently met Marcel Duchamp, the artist who first declared readymade objects, such as urinals and bottle racks, works of art. *Thermometer* pays homage to the famous work by Duchamp, *Why Not Sneeze, Rose Sélavy?*, 1921, which also includes a thermometer.

Thermometer, 1959, Jasper Johns, American, born 1930, oil on canvas with thermometer, 51¾ × 38½ in.

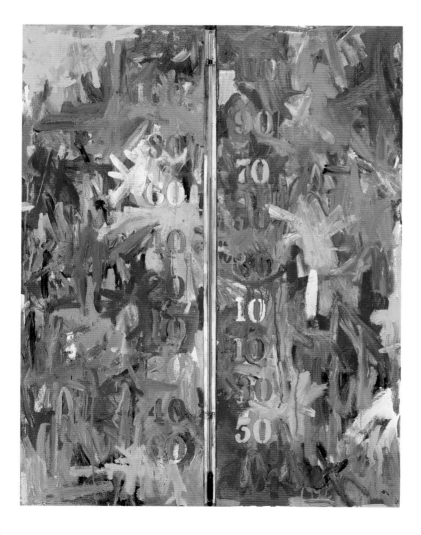

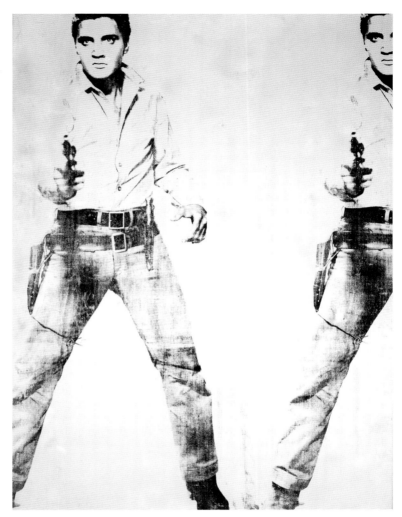

Double Elvis (detail), 1963, Andy Warhol, American, 1928–1987, acrylic on canvas, 82¼ × 59⅛ in.

Elvis Presley and Marilyn Monroe were Andy Warhol's favorite celebrity subjects. This painting was first presented in a gallery filled with Elvis paintings, all based on the same publicity still from Elvis' 1960 film, *Flaming Star*. Warhol placed identical images of Elvis on a silver background that evokes the silver screen, his double image suggesting the abrupt editing technique known as the "jump cut." Photo-silkscreening enabled the artist to incorporate repetitive images from popular culture, such as this one, directly into his paintings, challenging the idea of art's uniqueness. Painted the same year Warhol established his legendary studio, the Factory, this larger-than-life *Double Elvis* reveals nothing of Elvis Presley's personality, but speaks volumes about his compelling, Hollywood-manufactured persona.

SOCIAL STUDIES

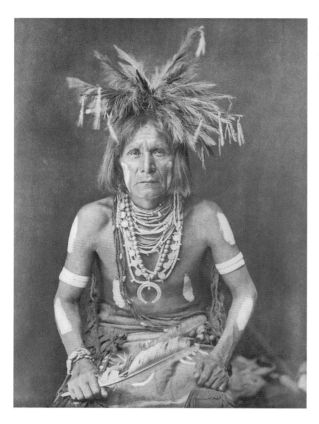

A Snake Priest, 1900, Edward S. Curtis, American, 1868– 1952, photogravure, 17½ × 12¹³⁄₁₆ in.

One of the first and most enduring preoccupations of photography has been the human subject. Our collective fascination with the peculiarities of other people's lives found a perfect medium in camera and film, bringing back images of far away places and unfamiliar rituals long before *People* magazine made voyeurs of us all. SAM's extensive photography holdings bear this out—ranging from the ethnographic to the ironic, artists have trained their cameras on their fellow human beings to capture the differences and similarities between us. Edward S. Curtis, for instance, has left a lasting and extensive folio of photographs of Native Americans, the result of thirty years' work recording the region's inhabitants and natural environment, which today paradoxically can also be perceived as products of exoticization and colonization. The anthropological and aesthetic value of Curtis' work is, however, undisputed and forever part of a distinguished tradition of photographers who sought to catalogue different social, economic, and geographical characteristics.

The critical, insightful approaches of later generations of photographers such as Robert Frank, Helen Levitt, and Max Yavno brought the subtleties of everyday American life into focus, while others like E. J. Bellocq, Diane Arbus, and Danny Lyon found compelling portraits in areas that were either too uncomfortable or simply inaccessible to the average person. The allure of the family portrait and its underlying—and universal—genealogical structure also helps explain the power of Nicholas Nixon's series of pictures of the Brown sisters, tracing familial traits while at the same time documenting the relentless march of time.

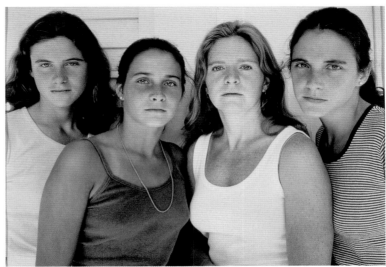

The Brown Sisters, Harwichport, Massachusetts, 1978, Nicholas Nixon, American, born 1947, gelatin silver print, 8 × 10 in.

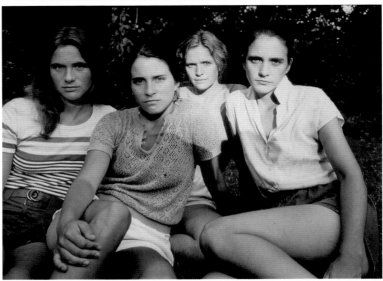

The Brown Sisters, Cincinnati, Ohio, 1981, Nicholas Nixon, American, born 1947, gelatin silver print, 8 × 10 in.

NORTHERN LIGHTS

Working in Seattle in the 1940s, Mark Tobey developed his distinctive calligraphic style—a unique integration of painting and writing—which reached its height in this ambitious, almost mystical painting, one of the artist's largest works. Painted one year after his successful retrospective exhibition at New York's Museum of Modern Art, *Parnassus* takes its title from the mountain visited by Greek artists of poet and song. Of this painting Tobey once said, "Obviously it is about a mountain, a small mountain, and there are some people on top and some below. A relationship between those on top and those below exists and has meaning. Just what is the meaning is for the viewer to determine. He will have to look at the painting for some time to become accustomed to the colors and to see the many figures and shapes, the lines of reality."

The first American to work in the famed Venini Factory in Murano, Italy, Dale Chihuly revolutionized American glass-making when he returned by introducing artists to the collaborative practices traditional to Italian masters. Together with Anne Gould Hauberg and John Hauberg, he established The Pilchuck Glass School in Stanwood, Washington in 1971; this rustic studio soon developed into a gathering place for international artists to share ideas and techniques. Titled after the Italian word meaning "stain, spot, or sketch," Chihuly's *Macchia* celebrates artistic vision and technical virtuosity. Part of a series begun in 1981, *Macchia* is built of many layers of opaque and transparent surfaces, its undulating contours and asymmetry embodying the spontaneity and fluidity of living forms.

Pink Macchia (single), 1986, Dale Chihuly, American, born 1941, blown glass, 17½ × 26 × 25 in.

(opposite)
Parnassus, 1963, Mark Tobey, American, 1890– 1976, oil on canvas, 82¹/₁₆ × 47³/₈ in.

PORTRAITS OF HUMANITY

"By looking at her [Augusta Savage] I understood that I could be an artist if I wanted to be."

—Gwendolyn Knight Lawrence

Their lives as husband and wife were closely entwined, yet the art of Gwendolyn Knight Lawrence and Jacob Lawrence remained distinctly different in style and conception. Gwendolyn especially enjoyed creating intimate portraits of loved ones and interesting strangers, using these faces to explore her reactions to color and materials as well as to their personalities. For Jacob, people were a reflection of their cultural heritage, so African-American lives and events in history—of both ordinary folks and heroic figures—became his subjects. The epic story of a people's oppression and liberation, which he expressed so memorably in bold, graphic compositions, was told through a series of powerful interconnected images.

Gwendolyn Knight, ca. 1933–1937, Augusta Savage, American, 1892–1962, painted plaster, 18½ × 8½ × 9 in.

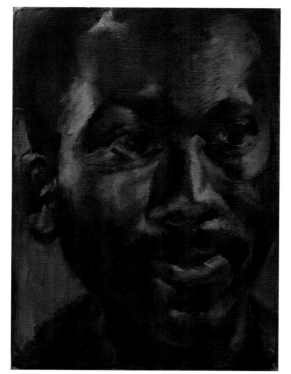

Jacob, 1986, Gwendolyn Knight Lawrence, American, born Barbados, West Indies, 1913–2005, oil on canvas, 14 × 10 in.

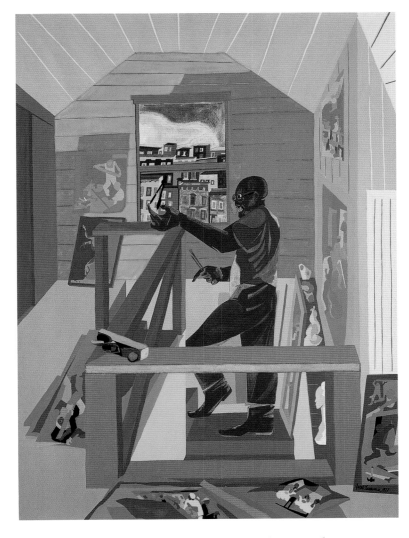

The Studio, 1977, Jacob Lawrence, American, 1917–2000, opaque and transparent watercolor on paper, 30 × 22 in.

"It's very interesting seeing people's studios and how they work. You can get a feeling for the artist's personality." —Jacob Lawrence

The art of these two very different painters nevertheless reveals a common bond—a shared devotion to humanity. The couple met in 1934 at the Harlem Community Art Center. One of the great catalysts in both their lives was the European-trained portrait sculptor, Augusta Savage. Her influence was as much through her dedication to young people in the Harlem community as it was through her art. The Gwendolyn Knight Lawrence and Jacob Lawrence Gallery preserves the legacy of these two painters and what they have given to the city of Seattle through their art, their teaching, and their support of the Seattle Art Museum.

BIRDS OF A FEATHER

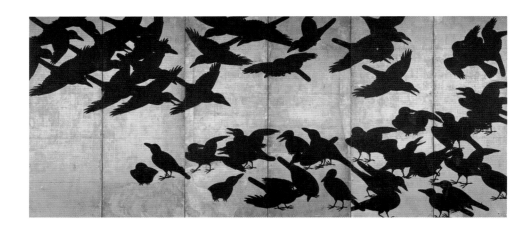

The depth of knowledge and passion for Asian art that SAM founding director Richard Fuller possessed profoundly influenced art and taste in Seattle from the time the city's art museum opened in 1933. Something of the aesthetic sensibility that shaped the museum collection and the creative direction of many of Seattle's artists during his tenure can be seen here in the visual interplay of three early acquisitions: Morris Graves' 1933 *Moor Swan,* the first purchase from the museum's Northwest Annual exhibition; Hunt Diederich's fanciful cocks-and-crows design fire screen, a decorative object acquired around 1933 that enhanced the museum's modern art deco style architecture; and the magnificent seventeenth-century Japanese *Crows,* which Dr. Fuller purchased in 1936 and undoubtedly would have served as a source of inspiration, imagination, and innovation for generations of artists and museum visitors, and continues to do so today.

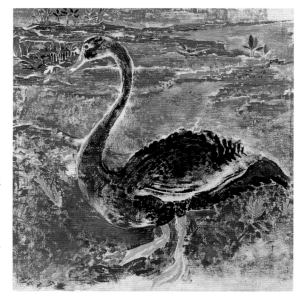

Moor Swan, 1933, Morris Graves, American, 1910– 2001, oil on canvas, 36 × 34¾ in.

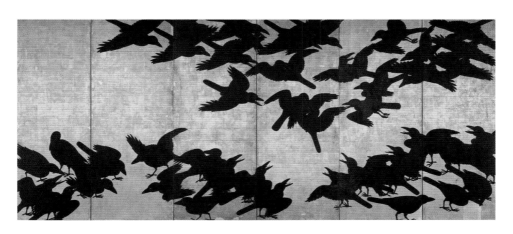

(opposite, above)
Crows, Japanese,
ca. 1650, Edo
period (1615–1868),
a pair of six-panel
screens, ink and
gold on paper,
ea. 61¾ × 139 in.,
overall h. 68½ in.

 Dr. Fuller generously gave his support to, and seemed naturally to draw around him, Seattle artists such as Morris Graves, among others, whose painting and personal philosophy were shaped by the transformative experiences he first had as a youth on his travels and studies in Japan. In the case of American sculptor Hunt Diederich— although not a personal acquaintance— Dr. Fuller still favored contemporary works such as Diederich's, whose linear rhythms and strong graphic qualities were akin to the simple forms of Chinese or Japanese paintings and objects.

*Fire screen: Cocks
and Crows*, ca. 1930,
William Hunt
Diederich, American,
born Hungary,
1884–1953, wrought
iron, cut sheet
metal, and brass,
41⅝ × 39¾ × 7¾ in.

A NEW GOLDEN AGE

In nineteenth-century America, Greek and Roman art and ideals were rediscovered and reinterpreted as apt symbols of a nation's new Golden Age, strikingly apparent in the visual correlations of these three superb works.

In this cabinet, extraordinary in every aspect, designer Christian Herter used elements such as gilded roundels typically associated with Roman and Byzantine adornments in architecture and Classical attire, and the elaborate garlands of flowers and fruits that once decorated the frescoed walls of wealthy Romans. The boldly carved heads, incorporated atop miniature columns at the corners of the cabinet, function the same way as Greek architects once used caryatids—female figures bearing the weight of the world—not as column adornments but as actual columns. This graceful marble caryatid is a Roman copy of the Greek original, an even earlier attempt to convey a new Golden Age through the art of the past. The unknown Roman artist was supremely skilled in carving a hard medium into the softest folds of the sensuously draped garments.

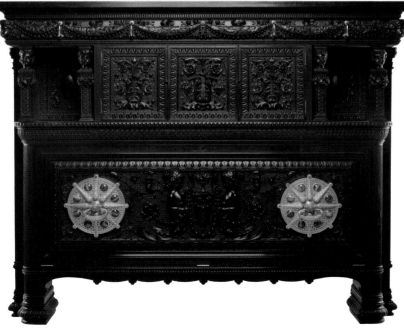

(above)
Caryatid, Roman, 1st century, marble, 23¾ × 8¾ × 6½ in.

Ebonized Cabinet, American, New York City, ca. 1881–1882, Herter Brothers (Christian Herter), active 1864–1906, ebonized oak, brass, gilded bronze, and agate, 60½ × 75¾ × 13¼ in

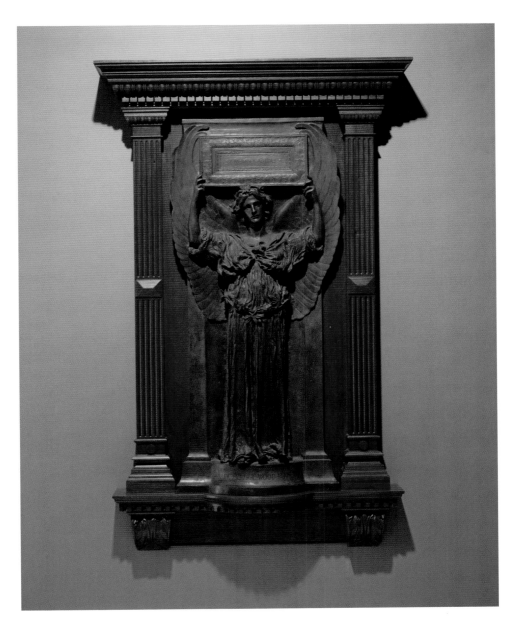

Similar models of Classical sculpture influenced Augustus Saint-Gaudens in developing his *Amor Caritas*. He was fascinated by the air of naturalism and perfect balance in Greek and Roman figures. To emulate the elegant, languid flow of deeply cut Classical drapery folds, he modeled *Amor Caritas* in high relief. Here, Saint-Gaudens has exalted feminine beauty as a symbol of what he considered to be the greatest measure of humankind: our potential for love and charity, or, in the language of ancient Rome, our capacity for *amor caritas*.

Amor Caritas, 1898, Augustus Saint-Gaudens, American, born Ireland, 1848–1907, bronze, lost wax cast, 39⅜ × 17 × 4½ in.

SPIRIT OF PLACE

"The cultivated [landscape] must not be forgotten . . . its quieter spirit steals tenderly into our bosoms mingled with a thousand domestic affections and heart-touching associations—human hands have wrought, and human deeds have hallowed all around."

—Thomas Cole, "Essay on American Scenery," 1836

A Country Home was one of the most acclaimed paintings of Church's early career. The subject was one that had intrigued Church for years, after his first summertime rambles in 1848 in southern Vermont, the rural landscape on which the composition is loosely based. What was it about rural scenery that Church, many of his fellow artists, and his audience found so compelling in the 1850s? In part, the settled landscapes of old New England were expressions of a population's pioneer spirit, a congenial view sustaining the perception of America as a land of enduring peace and plenty, the reward of self-reliant country folk piously devoted to nature.

A Country Home, 1854, Frederic Edwin Church, American, 1826–1900, oil on canvas, 32 × 51 in.

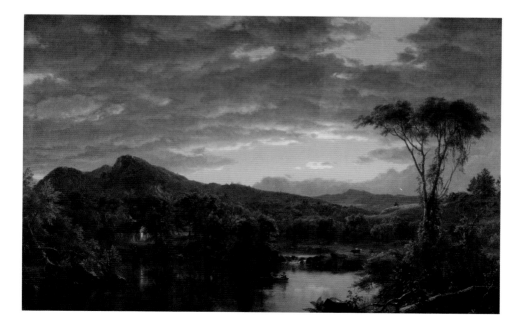

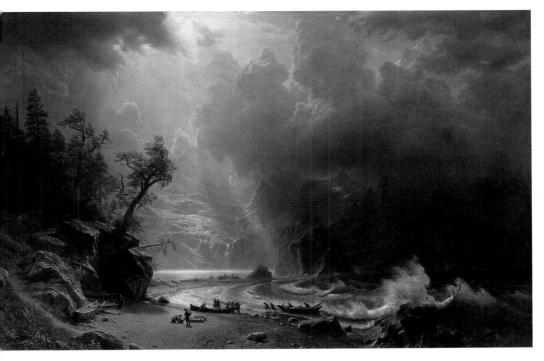

Rarely did Albert Bierstadt paint American landscape's "quieter spirit." He created highly theatrical works, favoring subjects in which landscape and nature overwhelm us. He was a great adventurer, and his name remains linked with dramatic views of the West.

Puget Sound on the Pacific Coast, 1870, Albert Bierstadt, American, born Germany, 1830–1902, oil on canvas, 52½ × 82 in.

Bierstadt boldly called this imaginary scene a view of Puget Sound. One enthusiastic reviewer believed this painting represented a faithful "portrait of a place," but Bierstadt had not yet traveled to the Washington territory when he chose to interpret it as a subject in 1870—his previous travels had imbued the artist with the essential spirit of the American West, at once thrilling and terrifying in its vast spaces, unknown terrain, and wild nature.

"He who stands on the mounds of the West, the most venerable remains of American antiquity, may experience the emotion of the sublime."

—Thomas Cole, "Essay on American Scenery," 1836

AMERICAN AFFLUENCE

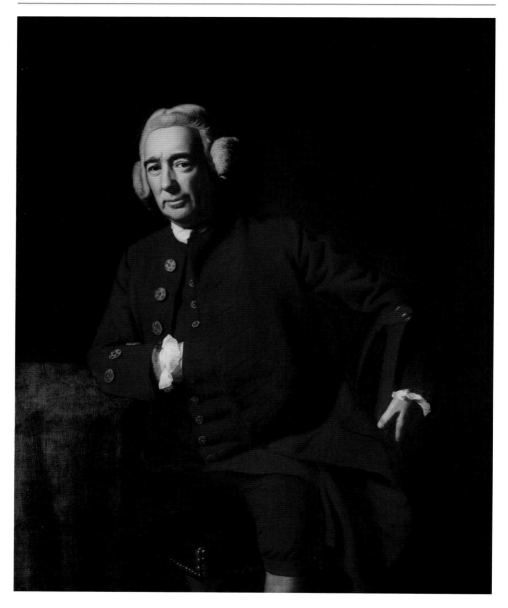

The growing fortunes of Boston's merchant class in the 1700s created a demand for the highest quality material goods that could be imported from London or produced by Colonial silversmiths, furniture makers, and portraitists to satisfy their increasingly sophisticated tastes.

John Singleton Copley was admired by Boston's elite as a highly skilled painter of likenesses, and he dutifully painted them as men and women

Sylvester Gardiner (1708–1786), probably 1772, John Singleton Copley, American, 1737–1815, oil on canvas, 50 × 40 in.

of wealth and taste. Their material finery—
from the beautiful fabrics of their garments
to their elegantly carved mahogany chairs
and tables—was portrayed with a realism
that still amazes.

Sylvester Gardiner was one of the most
learned men of medicine in the Colonies,
and a close friend of the artist, a familiarity
we glimpse in his bemused expression. Only
two years after this portrait was made, both
Copley and Gardiner, who remained loyal to
the British crown, were forced to flee Boston
under intimidation from those calling for
revolution.

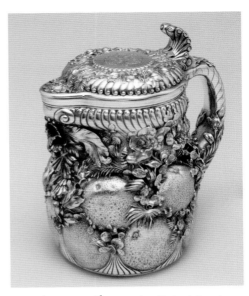

The three-quart tankard by Jeremiah Dummer ranks among the rarest
objects in American silverwork because of its impressive size and unusual
decoration. The chased, fanciful floral and bird designs on the tankard
were adapted from imported Asian textile motifs. Catering to America's
continuing fascination with things exotic, the Tiffany tankard was given
a Chinese-sounding name, "Son Chow," and decorated in high relief
with botanical forms from southern climes: oranges, cacti, palm fronds,
banana leaves, and magnolia flowers. This showpiece was created for the
World's Columbian Exposition held in Chicago in 1893.

Tankard, American
(New York), 1893,
Designed by John T.
Curran, 1859–1933,
Tiffany and Com-
pany, sterling silver,
h: 10 in.

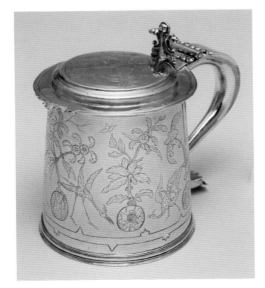

Tankard, American
(Boston), ca. 1685,
Jeremiah Dummer,
1645–1718, sterling
silver, h: 8¾ in.

MYTHIC THUNDERBIRDS

Interior house posts, expressively carved and painted by the artist Arthur Shaughnessy (Hemasil.ak^w) from the heartwood of western red cedar, were originally structural members of a longhouse erected in 1915 by John Scow on the central British Columbia coast. A special dedication potlatch—ceremonies that were banned by the government in 1921—was later held to validate the family's origins, mythic connections, and great deeds, references that were visually depicted on the exterior house painting and on the house posts. Paired posts (one shown here) originally at the back of the house feature spectacular thunderbirds with outstretched wings, perched atop a crouching bear.

The work of Calvin Hunt, who was born five years after the anti-potlatch law was dropped in 1951, has been a touchstone for many emergent artists as well as for the survival and revival of ceremonies, songs and dances. He grew up in the company of his legendary artist grandfather, Mungo Martin, uncles, aunts, and cousins, many of whom are active artists and ceremonial practitioners. Calvin's *Thunderbird Transformation mask and regalia* represent an inherited family crest brought out during the *tla'sala* dances performed during a feast or potlatch. This striking ensemble has its roots in the theatrical character of Kwakwaka'wakw performance where moving appendages, contrasting patterns of color and materials, and a complex combination of beings re-create mythological events.

Interior House post (Dłam), ca. 1907, Arthur Shaughnessy (*Hemasil.ak^w*), *Kwakwaka'wakw*, Dzawdǫ'enuxw Band, 1884–1945, red cedar and paint, 180 × 132 × 34 in.

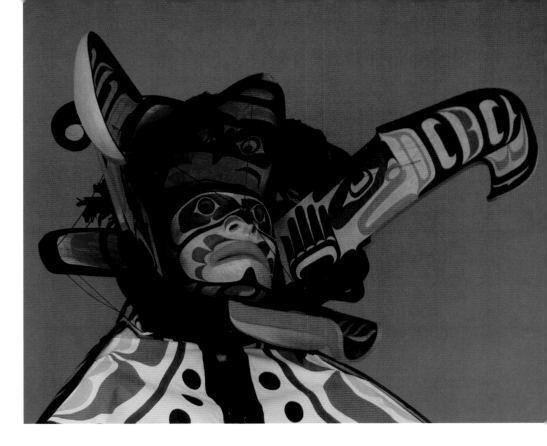

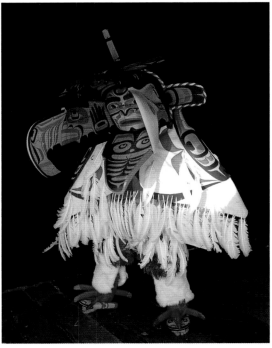

*Thunderbird
Transformation
mask and regalia*,
2006, Calvin Hunt,
Kwakwaka'wakw,
Kwagu'l Band,
born 1956, wood,
paint, ostrich and
turkey feathers,
rabbit fur, and cloth,
87 × 54 × 32 in.

ARTFUL ADAPTATIONS

The ancient, sophisticated surface art practiced by Northwest coast peoples—called "formline" design—is used to depict the human, animal and supernatural creatures that illustrate family origins and histories. Over time, innumerable adaptations have developed, including the creative improvisations of women weavers using the luxurious fibers of the mountain goat and the native yellow cedar. Working from a partial pattern painted on wood by their male artist counterparts, the weavers coaxed the geometric forms of their basketry and earlier weaving styles into figurative designs that were braided onto robes and special garments such as this *Bear Shirt*. This masterful example of a crouching sea bear with upraised paws manifests the formline hallmarks of beauty and simplicity: crisp black lines delineate the supernatural creature's commanding profile, enclosing the secondary shapes of the bear's internal and external anatomy.

Bear Shirt (Xoots kudas), Tlingit, ca. 1860, mountain goat wool, yellow cedar bark, wood plugs, and dyes, 43 × 25 in.

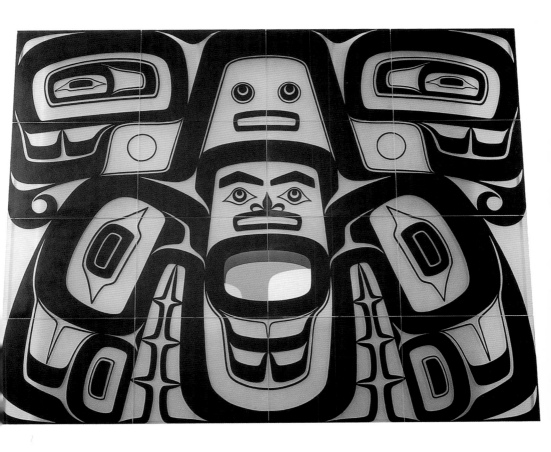

Keet Shagoon (Killer Whale screen), 2004, Preston Singletary, Tlingit, born 1963, fused and sand-carved glass, 72 × 92¾ in.

One thousand miles south and one hundred fifty years later, the same design ethos that empowers the woven shirt is stunningly presented anew in this monumental work made up of sixteen panels of sandblasted glass by Seattle-based artist Preston Singletary. In the early 1990s Preston reoriented his considerable knowledge of world glass traditions and techniques to include Tlingit imagery and forms. With the same experimental spirit as the weaver, Preston presents one of his family's crests, the killer whale, in a bold abstracted design. When compared to the traditional elegant pose of the sea bear, the projected power of the whale—whose shape has been divided and splayed symmetrically across the luminous surface—is evidence that Singletary's work signals a modern moment for an ancient art form.

TRADITION AND INNOVATION

Shortly after contact with Euro-Americans in the late-eighteenth century and still practiced today, Haida artists demonstrated their abilities to adapt to new materials, new techniques and new markets. Robes fashioned from Hudson's Bay Company cloth and embellished with pearl buttons eventually replaced the older robes of cedar fiber, fur, and hide. Designed by men and fabricated by women, robes bear the clan crests that proclaim the identity and lineage of the wearer, in this case a splayed orca whale.

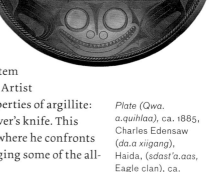

Argillite, a soft, fine-grained slate rarely used in pre-contact years, was transformed by highly skilled artists into artifacts such as elaborate pipes, model totem poles, figures and plates to appeal to the tourist trade. Artist Charles Edensaw masterfully exploits the unique properties of argillite: note the surface luster and contrast yielded by the carver's knife. This plate depicts one of Raven's many legendary exploits, where he confronts a supernatural creature who holds the secrets to changing some of the all-male population into females.

Plate (Qwa. a.quihlaa), ca. 1885, Charles Edensaw (*da.a xiigang*), Haida, (*sdast'a.aas*, Eagle clan), ca. 1839–1924, argillite, 12¹⁵⁄₁₆ × 2¼ in.

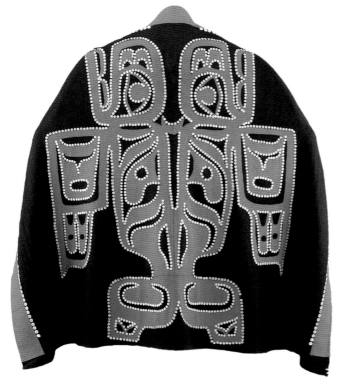

Button Robe (Guu-laangw gyaat'aad), ca. 1890, design attributed to John Yeltadzi, Kaigani Haida, commercial wool cloth and pearl buttons, 54 × 70 in.

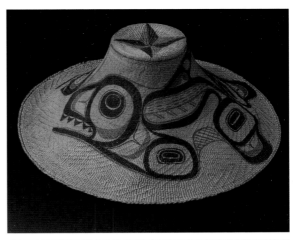

Painted woven hat (Xaad dajaangaa), 1895, Isabella Edensaw (*qwii. aang*), Haida, (*yahgu'laanaas,* Raven clan), 1858–1926, and Charles Edensaw, (*da.a xiigang*), Haida, (*sdast'a.aas,* Eagle clan), ca. 1839–1924, spruce root, and paint, 5½ × 17 in.

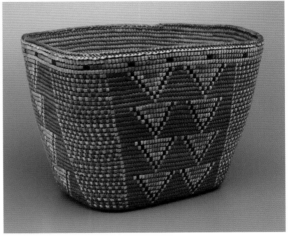

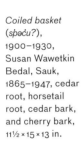

Coiled basket (sp̓əd̓u?), 1900–1930, Susan Wawetkin Bedal, Sauk, 1865–1947, cedar root, horsetail root, cedar bark, and cherry bark, 11½ × 15 × 13 in.

Collaborative male/female enterprises extended to woven spruce root hats, this one created by Isabella Edensaw and painted by her husband, Charles Edensaw. Isabella's highly refined technique is demonstrated in the lovely diamond-pattern twine weave of the hat itself while Charles' unique application of the formline design expresses the fluid quality of the painted rounded ovoids and U-shapes of the whole design.

Women weavers, like Isabella Edensaw and Susan Wawetkin Bedal, learned by observation and experimentation to transform humble plant fibers into aesthetic objects with functional uses, for cherished gifts and as artworks made for sale. The structure of Susan's firmly coiled baskets was ingeniously created by sewing together bundles of plant fibers, while simultaneously adding in the dyed, decorative elements. Family-owned designs, often derived from nature such as this butterfly design, reference the intimate connections that the Sauk people had with the natural habitat of the foothills of the Cascade Mountains.

SPLENDOR IN LIFE AND DEATH

Valued as articles of great prestige, Andean textiles, such as this unique four-cornered tasseled hat from the mountains of Peru, were considered more valuable than gold. Birds appear in profile, with the fluffy surface quality created by the knotted technique referencing their plumage. The hat was part of an elaborate ensemble that included colorful face painting and an intricately patterned tunic, so the wearer was virtually obscured. The still brilliant colors were produced with natural dyes—cochineal for the scarlet red and indigo for the blue—which are easily absorbed by the silky flexible fibers from llamas and alpacas. Andean textiles expressed status and authority in life and in death, as they were placed in tombs with the deceased; the climate in the arid coastal desert preserved them remarkably well.

Four-cornered hat, Peru, Wari, Middle Horizon, ca. 500–800, camelid fiber and cotton, h: 4½ in.

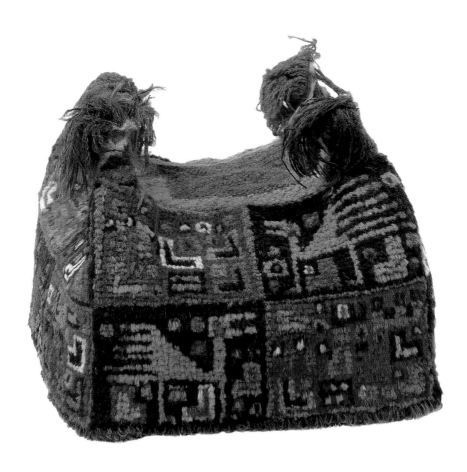

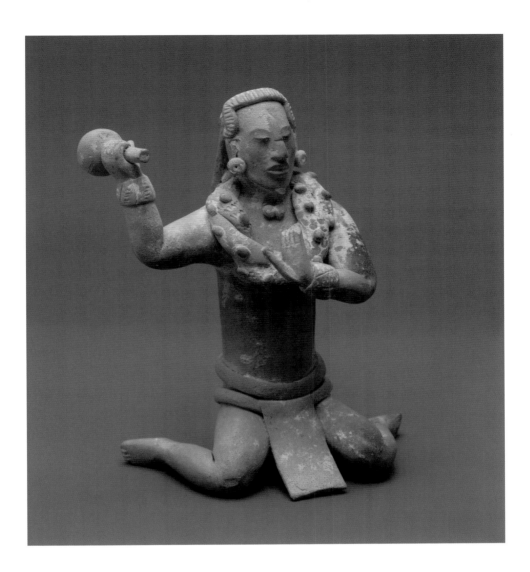

Figure with rattle,
Mexico, Maya,
Jaina, Late Classic,
ca. 600–900,
ceramic, 5½ × 4¼ in.

Thousands of ceramic sculpted figures made by Maya artists along the Campeche Coast and neighboring islands were interred with the high-ranking deceased on Jaina Island, a major necropolis for Maya nobility. The sculptors of these figures were recorders of their time, creating realistic portraits of the Maya people and illustrating distinctive aspects of their society, such as this figure's unique type of loincloth, which indicates the low status of a captive. Delicately modeled and intended as a burial object, it depicts a seated dancer who shakes a rattle with one hand and gestures with the other. Many of these figures also functioned as whistles or rattles—musical accompaniment for the afterlife.

SORRY BUSINESS

Paying final respects to a person can be expressed by placing him or her in a work of art. Here we see two very different ideas about how to say goodbye artistically.

"Sorry Business" is an expression commonly used in Australia when referring to death. In Arnemland, a ceremony using hollowed logs is the last offering made to the deceased. Each log becomes a canvas for designs with strong associations. Nurturing features of the landscape are evident—wandering whistling ducks, ghost sandcrabs, parrot fish, rock cod, and turtles. Framing them are crosshatched and linear-patterned mazes that can achieve a shimmering brilliance, or "singing" quality, to evoke ancestral power. So embellished, the log is said to swallow and absorb the bones put in it and enable the deceased to return to a mythic homeland.

From Ghana, what looks like a car on the outside has a removable lid with a turquoise satin lining inside. It proclaims the worldly success or source of income of a person, just as iconic images—of fish, cocoa pods, red peppers, screwdrivers, cell phones, and even fallopian tubes (for a gynecologist)—do. During a funeral, abundant appreciation for the deceased is offered with lavish refreshments, gospel and highlife music and a final procession that gives them a chance to go wherever they please for one last time.

These examples of tributes to the departed were made solely as works of art for public display and have never been used.

Hollow Log Coffins, natural ochres on hollow logs, Australian Aborigine, 1995–2001. Artists (left to right): Phillip Gudthaykudthaty, born 1935; Jimmy Angunguna, born 1935; Galuma Maymuru, born 1951; Baluka Maymuru, born 1947; Nawurapu Wunungmurra, born 1952; l: 4 to 8 ft.

(far right) Detail from Galuma Maymuru, 2001

Mercedes Benz Coffin, 1991, Kane Quaye, Ghanaian, 1922–1992, wood and paint, 25 × 35 × 101 in.

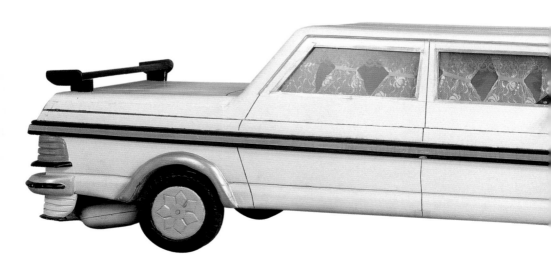

UTOPIA IN THE DESERT AND THE BILLABONG

Paintings by Aboriginal artists in Australia arise from the oldest continuous artistic tradition on earth, but appear modern in color and form. "Intellectual vertigo" is said to result as these landscapes offer unexpected vantage points of different environments.

Gathering Storm, 1993, Lin Onus, Australian, 1948–1996, oil on linen, 35⅝ × 47⁹⁄₁₆ in.

Swirling strokes of paint take the viewer underground to see wild yams that grow in the red sandy soil. It comes from a region named Utopia by colonists, who established a cattle station in what they deemed barren territory, while painter Emily Kame Kngwarreye and her family considered the land to be full of edibles, wild life, and sacred sites. After years of painting up bodies for ceremonies, she was introduced to acrylic paints at the age of seventy-eight and soon became a remarkably agile and prolific artist. As a senior custodian of the Yam Dreaming, she pays tribute to these tubers that serge through the soil but remain invisible to untrained eyes.

Layers of reflection appear in paintings by Lin Onus. Forest pools showcase his skills as a painter, but also pique the viewer's imagination about indigenous places. This is one of a series depicting different times of day in a billabong (or pond). In it, his admiration for the art of René Magritte is combined with a sacred hatching pattern called *rarrk*, which appears on the fish. Known as the "urban dingo" and "the reconciler," artist Lin Onus was the son of a Scottish mother and Aboriginal father, both political activists whose legacy was a broad spectrum of art and life for him to reference, expressed through his work.

Wild Yam Dreaming, 1995, Emily Kame Kngwarreye, Australian Aborigine, ca. 1910–1996, acrylic on linen, 59¹³⁄₁₆ × 48¹⁄₁₆ in.

STRONG CHARACTERS

Calligraphy, together with painting and poetry, composes the "three perfections" (*sanjue*), an ideal of creative expression through words and images, believed to reveal a person's knowledge and character. Oftentimes there was an assumption that the imitator of a famous calligrapher's style had acquired—and thus somehow shared—the celebrated heritage and values of the master. The *Poem to the Painting "Sunset on the Jin and Jiao Mountains,"* written on a handscroll in 1521 by the scholar-artist Wen Zhengming, is a reinterpretation of the calligraphy of the eleventh-century scholar Mi Fu. Wen's execution of large *xingshu* (running script)

Poem to the Painting "Sunset on the Jin and Jiao Mountains" (detail), 1521, Wen Zhengming, Chinese, 1470–1559, ink on paper, 14 × 390 in.

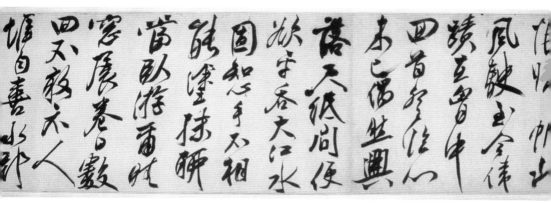

characters with elongated dynamic strokes preserves the rhythm of the calligraphy and captures the mood of the poem.

Poems and colophons are often inscribed in the same scroll alongside the painting or written on a separate scroll. The contemporary artist Li Jin has created his own innovative approach in *A Feast*, a sixty-foot hand-scroll featuring an essay on the importance of food in Chinese culture as well as regional recipes with lively illustrations of the dishes and ingredients. Gradations of ink—the essay in light ink and the recipes in dark ink—separate and delineate the vast array of colorful images and calligraphic elements interspersed from one end of the scroll to the other.

Without ink, the written word can still create a strong impact. In direct contrast with traditional calligraphy, in which wet ink is brushed onto dry paper, the Korean ceramic artist Yoon Kwang-cho meticulously incises the 269-character *Heart Sutra*—a favorite Buddhist text—on his stoneware by using an iron nail on the semidried coat of white slip daubed over the gray clay body. By highlighting the gray inscriptions on the cream-colored background, Yoon's inspired vase design transcends artistic expression and becomes a votive object as well.

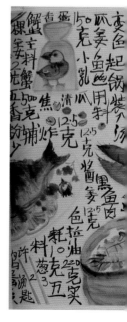

Heart Sutra, 2002,
Yoon Kwang-cho,
Korean, born
1946, stoneware
with white slip and
incised design,
20½ × 19⅝ × 9 in.

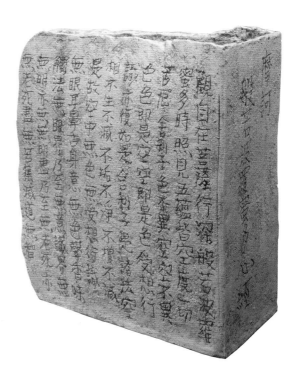

A Feast (detail),
2001, Li Jin,
Chinese, born 1958,
ink on Xuan paper,
39⅜ × 708⅝ in.

WAY OF TEA

The tea gathering in Japan was formerly practiced in a sumptuous style until the legendary tea-master Sen no Rikyū (1522–1591) originated a new way of tea called *wabi-cha*, using Korean and Japanese unadorned utensils and vessels in a small tatami-mat room of absolute simplicity.

The three-mat tearoom, *Ryokusuian* (Arbor of Green Reflecting Waters), installed in the Asian Art Gallery in 1991, was donated by the Urasenke Foundation, Kyoto, in commemoration of the 400th memorial year of tea master Sen no Rikyū. The room may look plain at a glance, but a closer

Ryokusuian, 1991

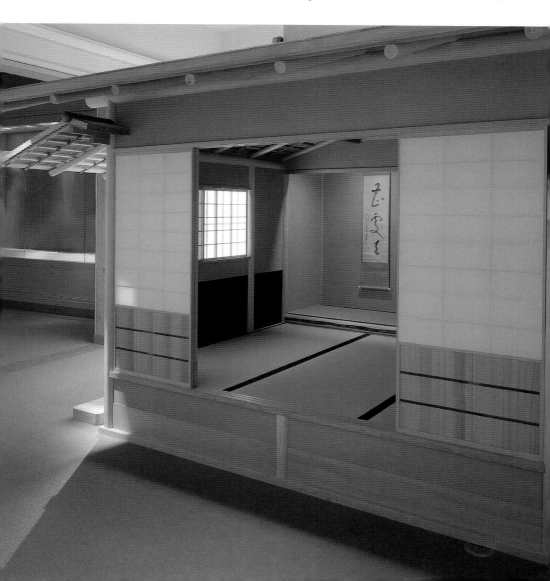

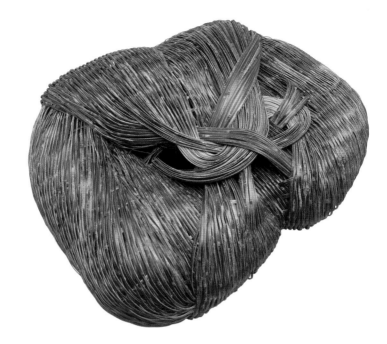

*Connecting
(Tsunagari)*, 2004,
Tanabe Takeo
(Chikuunsai IV),
Japanese, born
1973, bamboo,
15 × 40 × 30 in.

appraisal reveals how every material was carefully selected and incorporated by special craftsmen, creating an atmosphere of harmonious natural beauty.

Among the humble materials prized by tea participants, bamboo's remarkable adaptability and pliability allow it to be shaped into every imaginable form—as a scoop, a whisk, and various baskets and containers for flowers and charcoal—used in the tea room. *Chikuunsai* (literally, "bamboo-cloud") is a bamboo artist lineage that has created baskets, used for tea gatherings, which are true works of art. Tanabe Takeo (Chikuunsai IV) is the successor to his family heritage of bamboo techniques and philosophy, while exploring his own artistic style as a contemporary artist. He formed this dynamic supple shape using strips of *kurochiku* (black bamboo), leaving the surface unlacquered to reveal its unique natural texture and patterns.

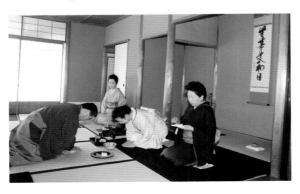

A tea gathering

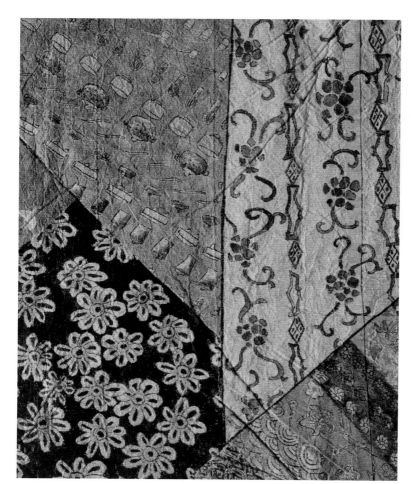

Vest with patchwork design (detail), early 20th century, Japanese, Meiji period–early Taisho period, paper and silk cloth, 30¼ × 14½ in.

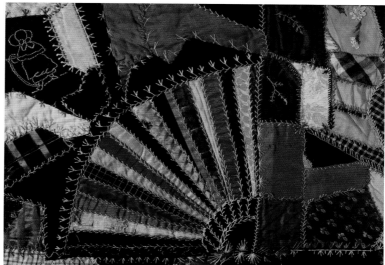

Crazy Quilt (detail), ca. 1887, American, silk velvet with metallic thread, jacquard woven silk, embroidery, and paint, 60 × 68 in.

COMPOSING WITH
BITS AND PIECES

Fragments of cloth, like the proverbial cat, have a way of re-appearing to lead another life. In this sampling of textiles, patches of cloth are sewn together in a multitude of patterns. Japanese Buddhist priests carefully restructure sections of silk kimonos. An American grandmother picks cloth loaded with memories to assemble a crazy quilt. African families pool swatches of European, Japanese, and locally handwoven cloth to create "breezes of blessing" in a masquerade costume. Recent artists make use of vast arrays of fabrics to create dazzling juxtapositions. From straight geometrics to wild collisions of color and design, this is a persuasive view of what is possible in the Textile Gallery.

Sylvia Plath Quilt (detail), 1980, Ross Palmer Beecher, American, born 1957, fabric and woodcut, 94 × 68 in.

Egungun Costume (detail), 1970s, African, Yoruba, Nigerian, Ogbomoso, cloth, fiber, wood, and metal, 68 × 76 in.

THE NEW FROM NEAR AND FAR

Constructed of 100,000 military-issue dog tags, Do-Ho Suh's *Some/One* suggests the armor of an ancient Korean warrior or a memorial to fallen soldiers. The idea for the sculpture came to the artist in a dream, but his interest in military insignia and symbolism derived from his mandatory military service experience in South Korea. *Some/One* is sited on the floor, not on a pedestal, and invites the viewer to walk on it and around it, to virtually inhabit the garment. The dog tags do not belong to specific individuals, a point the artist makes by typing random letters and numbers on each. Viewers' reflections in the metal surface temporarily supplant this sea of anonymity with particular identities. The title *Some/One* brings together the "many" with the "one"—some *one* may gain status through the collective, or lose individuality in the *many*, as the whole becomes a new entity.

Some/One, 2001, Do-Ho Suh, Korean (works in America), born 1962, stainless-steel military dog tags, nickel-plated copper sheets, steel structure, glass fiber reinforced resin, and rubber sheets, 81×126 in.

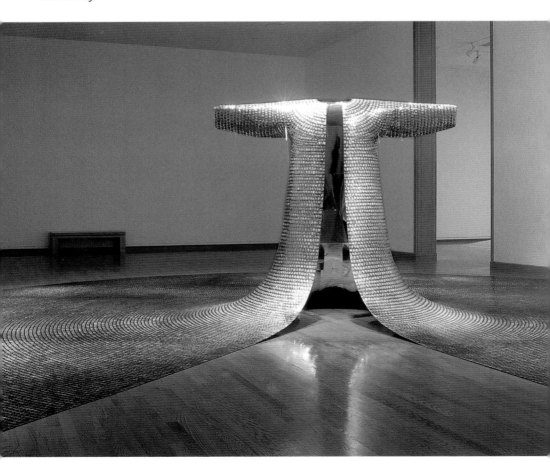

Egyptian-born artist Ghada Amer provocatively transverses borders
of culture, tradition, and propriety in her work, bringing together a
variety of recognizable motifs and methods to introduce new realms of
possibility. In works such as *Black Series: Coulures Noires*, she harnesses
the mystery of abstraction with the stark reality of images drawn from
pornography, uniting the handmade (which also includes embroidery)
with the readymade. As a woman artist from a predominantly Muslim
country, the combination of representational and erotic imagery is
particularly striking—if not heretical—within certain circles. Amer's
work is not merely an exercise in shock, however. Rather, it seeks to
build upon and push forward traditions of painting by positing a
more open, hybridized, and ultimately contemporary form of Abstract
Expressionism.

FOOD FOR THE EYES

A multitude of masks illustrate that faces and heads are central subjects for African art. What can't be seen in the quiet setting of an art museum is the artifact's true origination, an outdoor stage in which the mask becomes the face of children, mothers, heroes, policemen, noblemen, entertainers, spirits, and animals. Lively, mesmerizing performances

(left)
Crocodile Headdress, Cross River, Ekoi, wood, antelope skin, basketry, 29 × 38 in.

(below, left)
Bird Mask, Liberia, Dan, wood, 13 × 10 in.

(below, right)
Mask, Democratic Republic of the Congo, Luba, wood, pigment, 19 × 15 in.

(opposite, top left)
Mask (Kifwebe), Democratic Republic of the Congo, Luba, wood, raffia, bark, 36 × 24 in.

(opposite, top right)
Mask, Democratic Republic of the Congo, Ngbaka, wood, 11 × 8 in.

(opposite, bottom left)
Helmet Mask, Democratic Republic of the Congo, Kuba, wood, seeds, fur, 18 × 10 in.

(opposite, bottom right)
Mask, Democratic Republic of the Congo, Kuba, raffia, feathers, shells, fiber, 6 × 12 in.

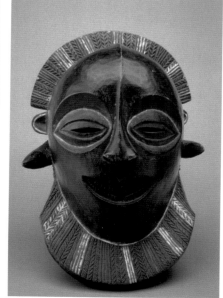

answer the questions posed by Adeboye Babaloa in 1996, "What do we call food for the eyes? What pleases the eyes as prepared yam flour satisfies the stomach? The eyes have no other food than the spectacle."

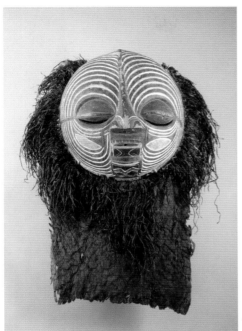

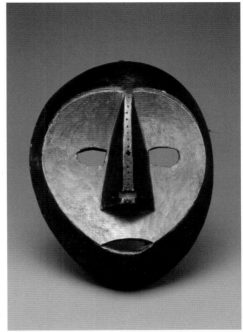

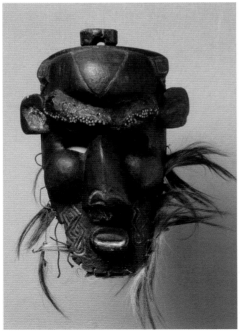

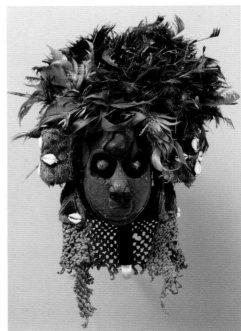

LICENSE TO MISBEHAVE

Masses of masqueraders appear in Afikpo, Nigeria, on a regular basis. One hundred or more costumed characters are given the license to behave in unusual ways towards each other and toward viewers—satire and ridicule of real persons and current events is expected, complete distortions or imaginary events are not. Corrupt leaders, loud women, henpecked husbands, or men who act like "rabbits of the night" become the subjects of humorous skits and songs. Errors of judgment and behavior are publicly aired and require those who are parodied to take it all in good humor. Parades of characters might also include Muslims, Catholics, European colonialists, priests, scholars, and married couples who walk side by side.

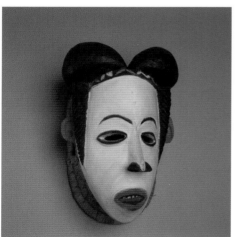

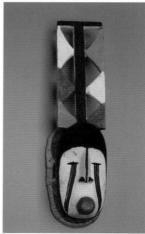

(far left)
Mask: Ibibio Style, 1953, African, Afikpo, Nigeria, Chukwu Okoro, Mgbom village, wood with raffia backing, overall: 10 × 6½ × 7 in.

(left)
Mask: Mba Mkpere Style, 1960, African, Afikpo, Nigeria, Chukwu Okoro, Mgbom village, wood with raffia backing, overall: 17½ × 4 × 5½ in.

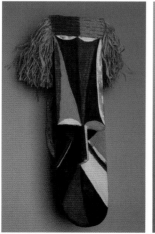

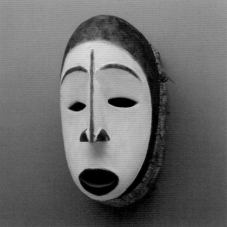

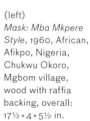

(far left)
Mask: Igri, Edda Style, 1960, African, Afikpo, Nigeria, Chukwu Okoro, Mgbom village, wood with raffia backing, overall: 20 × 9 × 5 in.

(left)
Mask: Beke, 1953, African, Afikpo, Nigeria, Chukwu Okoro, Mgbom village, wood with raffia backing, 9 × 5 × 6 in.

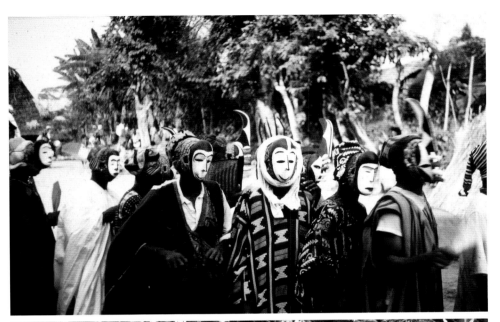

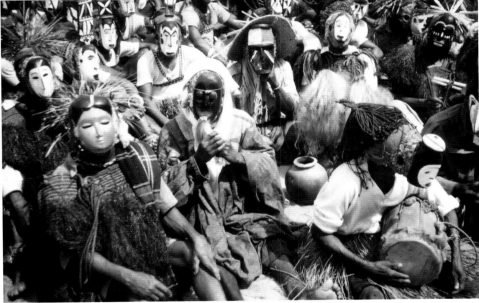

(top)
Njenje parade players,
Ndibe village,
Igbo peoples,
Afikpo Village Group, Nigeria

(above)
Okumkpa musicians and chorus,
Mgbom village,
Igbo peoples,
Afikpo Village Group, Nigeria

WRITING AS ART

Writing has been incorporated into art for as long as it has existed, using words to emphasize and describe figural scenes or dramatically highlighting text as an artwork's focus, on its own merit.

The hieroglyphs in Egyptian art serve dual purposes—they are both pictograms, images representing words and ideas, and captions for the figural scenes they accompany. In this richly colored 26th Dynasty grave stele, the inscription beseeches the gods for blessings, while graphically providing a patterned, striated "stage" upon which scenes are projected of Udjarenes—in whose tomb the stele was found—worshipping two deities.

No figures distract from the script's grace on a page from the Qur'an. Here, writing itself is the featured subject. The distinctive Kufic calligraphic script dances across the page—these are only words, but they are lively nonetheless. Blue-dyed vellum and gold-leaf script are highly valued materials used to convey the most precious subject: the word of Allah.

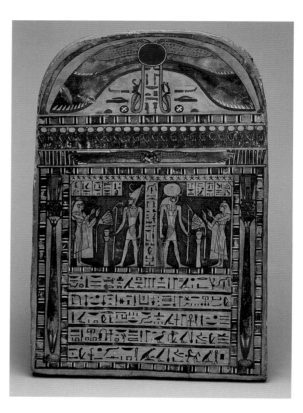

Funerary stele of the house-mistress Udjarenes, Egyptian, 664–610 B.C.E., Late Period (712–332 B.C.E.), 26th Dynasty, tempera and plaster on wood, 16¾ × 13 × 1 in.

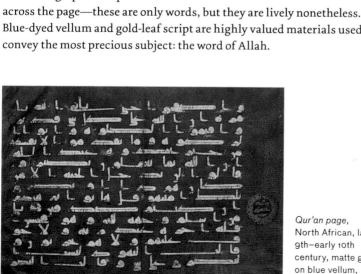

Qur'an page, North African, late 9th–early 10th century, matte gold on blue vellum, 9¾ × 13⅝ in.

ACHIEVING IMMORTALITY

This larger-than-life-size head of Claudius is not just a realistic image of an emperor—to awestruck Romans this was the face of a god. Carved after his death, when he was deified by his stepson and successor, the legendary Emperor Nero, originally the well-sculpted head was the crowning glory of a complete statue, sited prominently on public view to impress the cosmopolitan throngs passing by and ensure their eternal devotion.

The small Sumerian figure is also an image of a particular individual, a man commemorated as a mortal being and not a god. A wealthy patron would likely have placed the votive figure within a temple—intending it to be admired by the gods alone and not the general public—to trick the gods into thinking that it was he who dwelt in the temple in perpetuity and favor him for his constant piety. Even though the sculptor depicted him in a humble supplicant pose with hands locked in devotion, the statue still cuts a fine figure in elaborately tufted garments.

(bottom left)
Posthumous portrait head of the Emperor Claudius, Roman, 59–68, reign of Nero, third quarter of 1st century, marble, 17½ × 10½ × 11½ in.

(below)
Votive figure, Sumerian, Early Dynastic Period, ca. 2900–2500 B.C.E., alabaster, 11¼ × 5 × 3⅞ in.

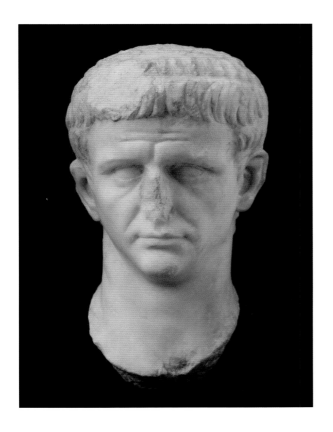

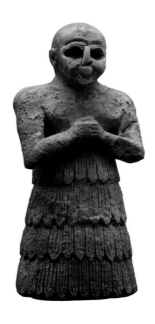

RENAISSANCE LEGACY

Walking into this stylish Italian room, surrounded by the warm rich color of mellow, aged wood, one experiences an almost magical suspension of time. Dating from the early seventeenth century in the northern Lombardy town of Chiavenna, the walls and ceiling are remarkably intact, creating an environment extraordinarily close to the original. The beautifully carved central ceiling panel, Corinthian capitals on fluted pilasters, and graceful swags of acanthus leaves make this room a work of art in itself. The museum's vibrantly colored sixteenth-century collection of Italian tin-glazed ceramic ware—known as *maiolica*—looks perfectly at home in this ideal setting.

Rendering of *Italian Room*, 1930, B. Mezo, watercolor on paper, 16 × 20 in.

Room interior and ceiling, Italian, ca. 1575–1600, wood and leaded glass, 171 9/16 × 200 5/16 in.

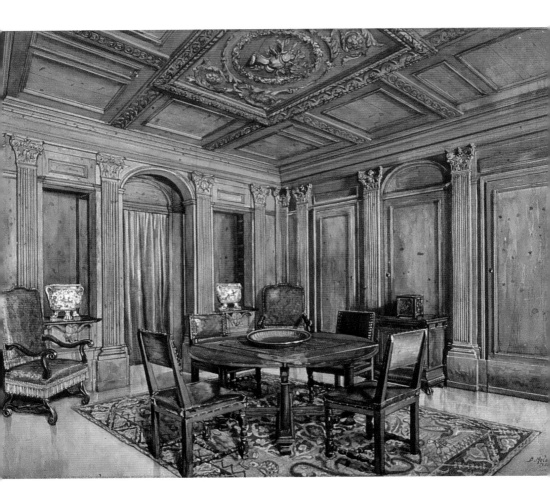

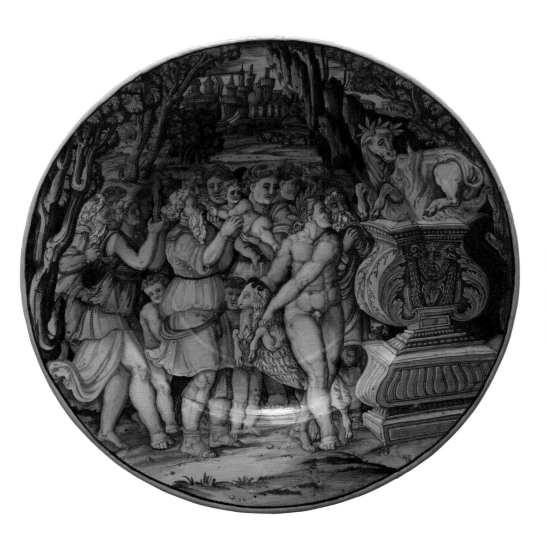

Plate, Italian, Urbino, ca. 1545–1550, Unidentified artist known as "Coalmine Painter," maiolica (tin-glazed earthenware), 2¼ × 15⅞ in.

Islamic potters of ninth-century Mesopotamia and Persia perfected an opaque glaze containing tin oxide, which gave their thin-walled, buff-colored pottery a white surface suitable for painted decoration. Over time, the tin-glazed technique spread to Moorish Spain and Renaissance Italy. The biblical theme on this Italian plate, the *Adoration of the Golden Calf*, is in a narrative style known as *istoriato* (literally, "storied"), that treats maiolica as a canvas—a ground for finely painted historical, biblical, mythological, and genre scenes that bring realism and perspective to ceramic art. Maiolica is still produced in Italy today.

LOVE IS A BATTLEFIELD

Love and conflict are inseparable in these two objects, produced more than two centuries apart. In the exquisitely carved ivory mirror back, a mock siege of the "castle of love" is enacted by men on horseback while ladies pelt them with roses, the flower associated with love.

The painting by Paolo Uccello was made to adorn the front of a marriage chest, or *cassone*, commissioned by a prominent Florentine family on the occasion of their son's wedding. For this union of two families, the artist chose not a theme of conjugal harmony but an episode from Virgil's epic poem, *The Aeneid*, which includes a battle between Aeneas' troops and a chaste warrior maiden named Camilla.

(below)
Mirror back, French, probably Ile de France, Paris, ca. 1330–1360, ivory, 4½ × 4¼ in.

(bottom and detail opposite)
Episodes from the Aeneid, ca. 1470, Paolo Uccello, Italian (worked in Florence), ca. 1397–1475, egg tempera and gold on wood, 16⅛ × 61½ in.

COVETING THY NEIGHBOR'S GOODS

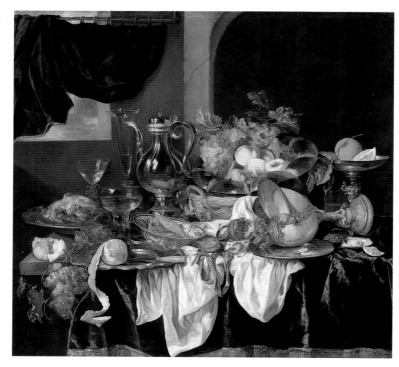

Banquet Still Life, ca. 1653–1655, Abraham van Beyeren, Dutch, 1620/1–1690, oil on canvas, 42⅛ × 45½ in.

Salt Cellar, Sapi-Portuguese, Sierra Leone, 15th–16th century, ivory, h: 12³⁄₁₆ in.

A glistening array of expensive vessels and colorful foods sprawls in luxuriant disarray across a table, the bountiful display a microcosm of the riches enjoyed by seventeenth-century Holland at the height of its dominance of world trade: Chinese export porcelain, imported fruits, Venetian-style glassware, Dutch silver, and a nautilus shell in a gilt mount. Like the exquisite ivory salt cellar from Sierra Leone, carved for the luxury market in Portugal, or the magnificent Asian-inspired tapestries, these extravagant items were enjoyed by consumers made wealthy by the European command of the seas.

A closer look reveals a despoiled atmosphere lurking below the surface of this casual abundance: tipped-over vessels suggest dissipated disorder, half-eaten foods will grow stale and go to waste, and a watch in the foreground reminds us that sensual pleasures are fleeting.

This ivory cellar commemorates a special moment in art history, when the Portuguese first encountered African

Tapestry: Three Deities (detail), Flemish (Brussels), commissioned in 1717, workshop of Judocus de Vos, 1661–1734, wool, silk, and metal threads, 105½ × 85⅟₁₆ in.

carvers and the aesthetics of two continents mingled. Portuguese explorers and West African ivory carvers both contributed to this unusual artifact's innovative mix of men and women whose combinations of facial features and dress are uniquely hybrid. They sit with erect posture and formal elegance awaiting their turn to contribute to the dining tables of Renaissance rulers.

As trade increased in the seventeenth century, Europeans became enthralled with visions of Cathay, as China was popularly known. *Three Deities* is one of our suite of four tapestries featuring chinoiseries, enchanting decorative motifs depicting imaginary interpretations of life in Asia—a fascinating synthesis of factual travel accounts and fantasy.

ROOM OF A
THOUSAND PORCELAINS

Today, the high-fired, durable, white-bodied ceramic—porcelain—is ubiquitous in our daily lives. Yet prior to the early eighteenth century, porcelain was a rarity, a treasured material produced exclusively in Asia. Beneath a Tiepolo-frescoed ceiling and filled with more than a thousand magnificent pieces of European and Asian porcelain, this contemporary installation evokes the great porcelain rooms found in late seventeenth- and early eighteenth-century European palaces where porcelain covered the walls from floor to ceiling. Rather than the traditional arrangement of porcelain by country and manufactory, our display is by color and theme.

Following years of experimentation to reproduce porcelain comparable to Chinese and Japanese wares, a formula was finally developed and high-fire technique perfected in Meissen, Saxony during the second decade of the eighteenth century. European porcelain production became a princely enterprise.

This vase belonged to the legendary Madame de Pompadour. As King Louis XV's mistress, this charming, bright, and ambitious woman established herself as the chief patroness of the arts in mid-eighteenth-century France and became one of the most influential persons in the court.

(above right)
Flower vase (cuvette à fleurs Courteille) French, Vincennes factory, 1755–1756, Louis-Denis Armand, active 1745–1783, soft-paste porcelain with enamel colors and gilding, 7¾ × 12¼ in.

(right)
European and Asian porcelain displayed by color grouping on one wall of the Porcelain Room

Certain privileged homes in the Venetian Republic were appointed with a delightful illusion: when you looked up, you saw not the ceiling, but the sky—eternally blue, infinite, and populated by celestial figures and creatures of the air. Tiepolo was the artist who created these enchanting panoramas, and his services were in demand throughout Europe. The Porto family of Vicenza commissioned him to create an image celebrating the family's long record of military prowess. After their approval of this sketch, the legendary painter executed a ceiling fresco spanning nearly seventeen feet. The fresco was removed from its site in the early twentieth century; it is now the crowning feature of SAM's Porcelain Room, where Tiepolo's original sketch can also be admired at close range.

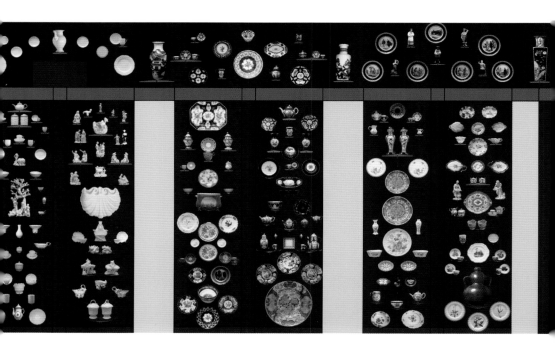

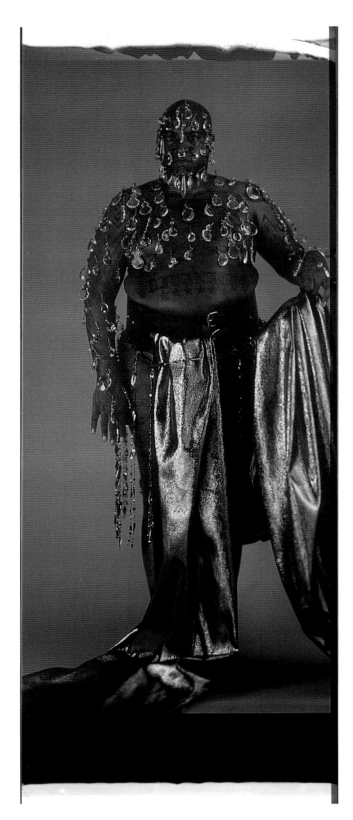

Untitled, Divinity,
2000, Catherine
Opie, American,
born 1961, photo-
graph, 103 × 43 in.

DOUBLE DIVINITY

Redefining the notion of what is divine, performance artist and actor Darryl Carlton, who is also known as Divinity Fudge, is seen in a portrait by Catherine Opie that is monumental in scale and impact. Prisms of a chandelier dangle from his head and body as if large drops of water. A tattoo inscribed in a typeface often used in the slave trade declares his name. Shimmering cloth adds the dramatic flourish of a champion prizefighter to his commanding appearance.

A figure whose eyes are covered with mirrors, the *nkondi* proclaims his ability to see beyond the surfaces of difficulties. Such figures serve among the Kongo people as diplomas for specialists who deal with social issues by offering divine insights to resolution. When they are concluding agreements between people, a nail acts as the signature to be pounded in and recorded on the *nkondi's* body. This powerful figure, and the one opposite, stands for far more than the simple typecasting of a fetish with pins and nails, an idea that is defiantly challenged by both men.

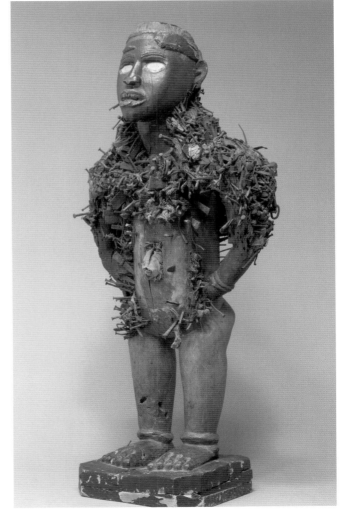

Standing Figure (Nkondi), late 19th–early 20th century, African, Democratic Republic of the Congo, Kongo, wood, iron, fiber, beads, string, glass, feathers, chalk, 32 × 13 × 9 in.

INSIDE LOOKING OUT

Europeans began exploring Africa in the fifteenth century, and thereafter Africans were portrayed in European art with some frequency, but typically as one of the trio of kings who were the "three wise men" in the biblical account of *The Adoration of the Magi*, or as a servant or member of a royal entourage. This portrait of an unidentified African man was painted by a French artist at a time when France was expanding its presence in Africa. While we can only guess the artist's opinion of French colonialism, he clearly admires this compelling individual, whose smoldering intensity rivets our attention.

Yinka Shonibare has said, "For me this purity notion is nonsense." He speaks English and Yoruba, has appeared as a Victorian dandy, and has lived in two very different cities, Lagos and London. Similarly, the *Nuclear Family* defies dichotomies. The mother's dress is Victorian in style but is made out of vivid, neon colors that would shock a nineteenth-century

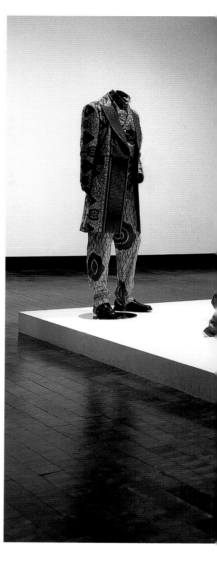

The Head of an African, ca. 1830, Paul Flandrin, French, 1811–1902, oil on canvas mounted on wood panel, 8 × 6¾ in.

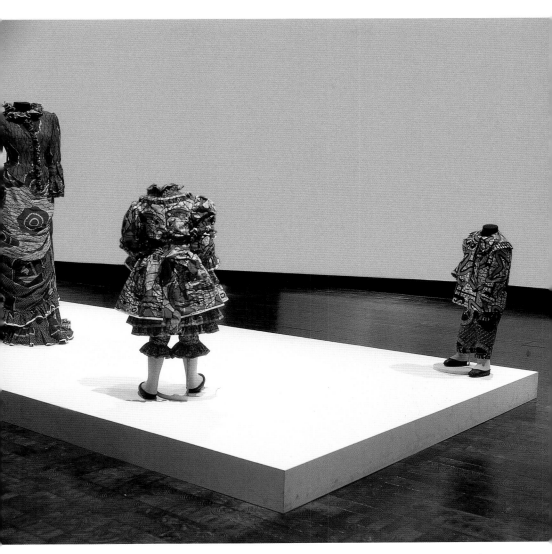

Nuclear Family, 1999,
Yinka Shonibare,
English, born in
Nigeria 1962, mixed-
media installation,
96 × 180 in.

English matron, as would the images of showerheads flowing water that
are printed on the fabric, which comes from Africa and Europe, but is
based on Indonesian cloth. Regarding the noticeable absence of heads,
the artist said, "It's a joke about the French Revolution—remember those
aristocrats who lost their heads?"

SEATTLE ASIAN ART MUSEUM
IN VOLUNTEER PARK

The Seattle Art Museum's original home, opened in 1933, remains one of the region's most widely admired and cherished architectural landmarks. Designed by Seattle architect Carl Gould, the art deco building is graced with exquisitely proportioned galleries which enhance the aesthetic impact of whatever works of art are shown there. The building originally housed the entire museum collection, which in the earliest days comprised Asian art and contemporary Northwest art. However, by the 1980s the collection had outgrown the facility, leading to the construction of SAM's present downtown site in 1991. Following an incremental plan of preservation, the original Volunteer Park building was renovated and reopened in 1994 as the Seattle Asian Art Museum.

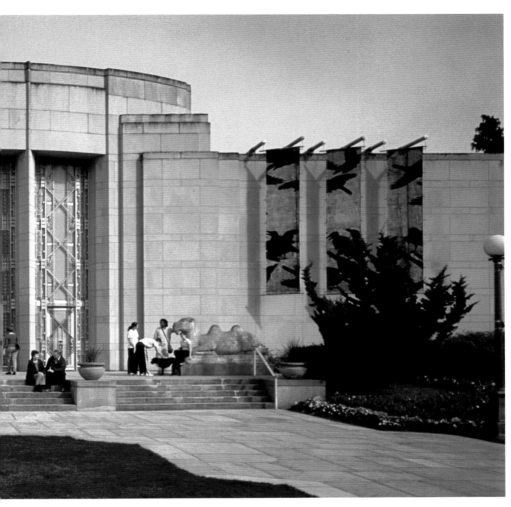

The museum's earliest collection was developed through the generosity of its founders and benefactors, Dr. Richard Fuller and his mother, Margaret Fuller, who in their extensive travels had built a collection of Asian art during the early part of the twentieth century. The museum showcases works from SAM's superb foundation collections of Chinese and Japanese art, with their strengths in funerary arts, ceramics, sculpture, and Buddhist art. Other collections have been introduced since Dr. Fuller's time and have flourished—the art of Asia is now also represented by works from India, Korea, Southeast Asia, the Himalayas, the Philippines, and Vietnam.

OLD IS NEW IN
17th-CENTURY JAPAN

Sometimes referred to as the Japanese Renaissance—from Momoyama (1573–1615) to early Edo period (1615–1868)—the early seventeenth century is the era when traditional art was revitalized, stimulated by the new patronage of powerful military generals, wealthy merchants and influx of fine craftsmen and artists in the cities. They sought beauty in the classic art cultivated by the aristocrats of ancient times, infused with a stylish and fresh design sense. The works of Hon'ami Kōetsu, Tawaraya Sōtatsu, and Furuta Oribe, three of the outstanding artists active in this epoch, are exquisite examples of this shared aesthetic.

Kōetsu, born into a wealthy craftsman's family in Kyoto, learned the way of tea from tea master Furuta Oribe. He made his own tea bowls, developing unique designs for *makie* lacquerware, and originated his own calligraphic style. A type of stoneware that Furuta Oribe particularly favored, with freehand brushwork in iron oxide and copper green glaze, is known as Oribe ware. The artist Sōtatsu's talent for fine painting and design is evident in his collaboration with Kōetsu, *Poem Scroll with Deer*. He elegantly depicted various types of deer, a visual symbol of the autumn season, by using only gold and silver pigments, and Kōetsu wrote the accompanying *waka* poems on autumn's melancholy. Contrasts in the ink brushwork give a unique rhythm to his calligraphy, in perfect harmony with the deer image. Kōetsu's diverse artistic accomplishments combine beautifully in this domed writing box, with *makie* and inlaid designs of stylized cranes in various poses amongst the reeds.

Poem Scroll with Deer (detail), Calligraphy: Hon'ami Kōetsu (1558–1637), Painting: Tawaraya Sōtatsu (active early 17th century), Japanese, early 17th century (Momoyama–Edo period), hand-scroll: ink, gold, and silver on paper, 13⅜ × 366 in.

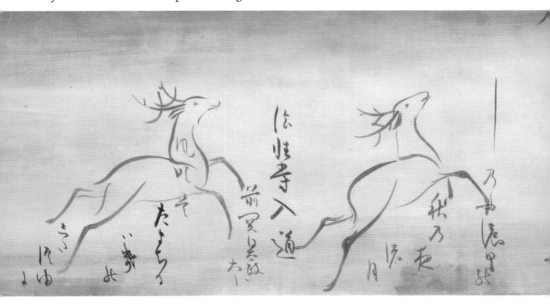

Writing box, attributed to Hon'ami Kōetsu (1558–1637), Japanese, early 17th century (Edo period), lacquered wood with lead and pewter inlaid, 9¼ × 8½ × 3¼ in.

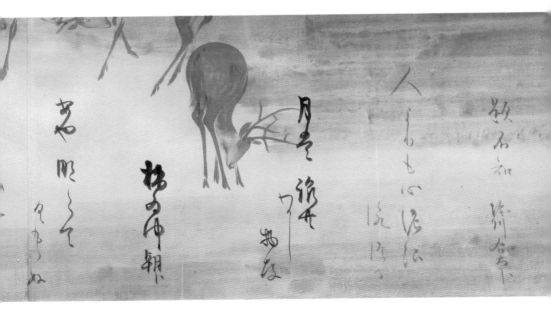

ANCIENT ARTISTRY OF CHINA AND BEYOND

Among the many Asian artworks that have entered the museum collection in the past seven decades, Chinese ceramics and bronzes have increased significantly to more than four thousand objects. During the 1930s, a type of bronze ritual vessel, called *jue*, became a coveted artifact for collectors such as Dr. Fuller, SAM's founder, although little was known about Chinese ritual bronzes at the time. The distinctive forms of bronzes—used for serving food and wine to the ancestors—were cast by means of molded sections. The main décor on these burial objects was a zoomorphic motif, whose meaning was known only to the ancients.

In addition to bronzes, China's remarkable development in ceramics naturally drew Dr. Fuller and his contemporaries to seek the finest examples that once adorned the palaces of imperial China. One such exceptional object is the copper-red vase commonly known in the West as the *Sang de boeuf* (literally, "oxblood"), manufactured during the Kangxi reign (1662–1722) in the early eighteenth century. The vibrant red glaze is achieved through meticulous control of the amount of copper to be added in the glaze, the inflow of oxygen in the kiln during firing, and the rate of heating and cooling—producing a rich depth of color that has been imitated, but not surpassed, in modern times.

Painting cobalt on porcelain is a classic ceramic palette and technique that the Chinese had mastered by the fourteenth century. The artists of Vietnam were among the first in Southeast Asia that attempted to reproduce this method, using a non-translucent clay body instead of porcelain. Vietnamese blue-and-white wares developed quickly and attained a high level of refinement during the fifteenth and sixteenth centuries. These ceramics, excavated in 1997–1999 from a shipwreck off the coast of Hoi An region, attest to the beauty and aesthetic appeal of the Vietnamese clayware.

(opposite)
Sang de boeuf vase, Chinese, early 18th century, Kangxi period (1662–1722), Jingdezhen ware (porcelain with copper-red glaze), 17¾ in. h.

(left)
Blue and White painted foliate rimmed dish, Vietnamese, late 15th–early 16th century, ceramic, 13¼ in. diameter

(below)
Libation cup (jue), Chinese, mid–late 2nd millennium B.C.E., bronze, 7⅞ w. × 7 in. h.

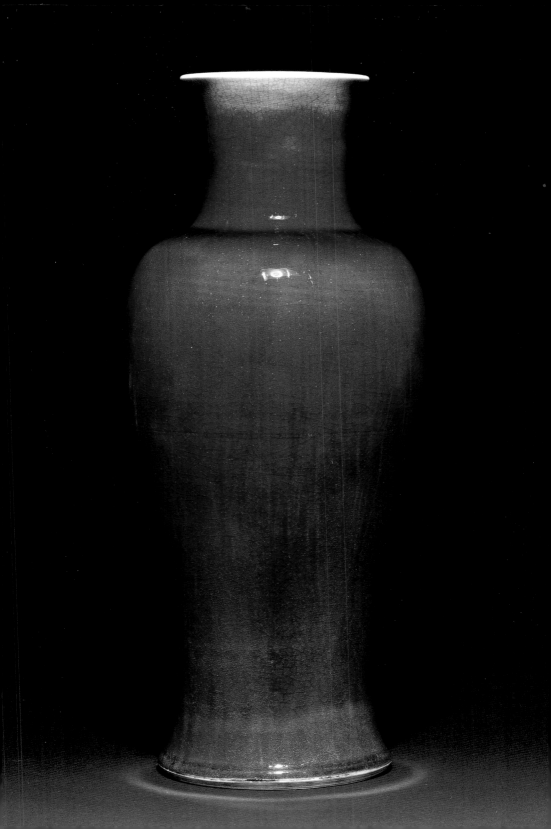

DIVINE INSPIRATION

Buddhism is a philosophical and religious movement begun in the sixth century B.C.E. by an ancient Indian sage named Siddhartha, known later as the Historical Buddha. After his worldly death, his bones and ashes were enshrined in burial mounds called *stupa*, his teachings were recorded as sacred texts, finally his visual image began to be created around second century A.D. at Gandhara and Mathura. Thus, from the third century, the dogma and sacred images of Buddhism spread throughout eastern Asia, co-mingling with the local beliefs and in doing so, unique religious art forms were born—each shaped by the local culture yet all inspired by the quest of seeking enlightenment and celebrating Buddhist teachings.

(below left)
Bodhisattva, Pakistan, Gandhara region, Kushan period, ca. 2nd–3rd century, dark grey schist, 45 × 15 × 7 in.

(below)
Buddha, Thai, Dvaravati style, 7th–8th century, gray-blue limestone, 44 × 17½ × 5 in.

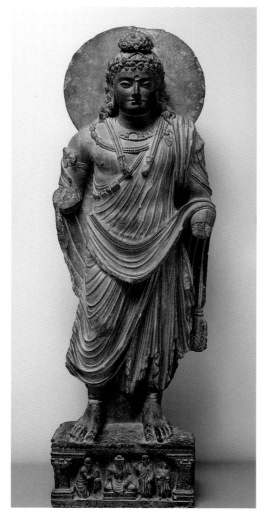

Buddhist imagery is manifest in remarkable variety and diversity—
sculptures, paintings, manuscripts, ritual utensils, created in India, China,
Tibet, Korea, Japan, and Thailand—as exhibited in the Garden Court and
Tateuchi Galleries, at Seattle Asian Art Museum in Volunteer Park.

Visual differences in the appearance or physical characteristics of
the representations depend upon the period of time and place or origin.
Gandhara's Bodhisattva was created under the influence of western
artistic tradition, which is known as Greco-Buddhist style. The tapering,
smooth modulations of the body and stylized facial features indicate
this Thai Buddha is an adaptation of a sophisticated style originating in
Mathura, India. A wooden statue of a Buddhist monk depicted in a
dynamic pose is that of Arhat, ("Lohan" in Chinese), a holy monk who
extended his life to preserve Buddha's teachings in this world. A perfect
balance between idealism and realism is embodied in this treasured work.

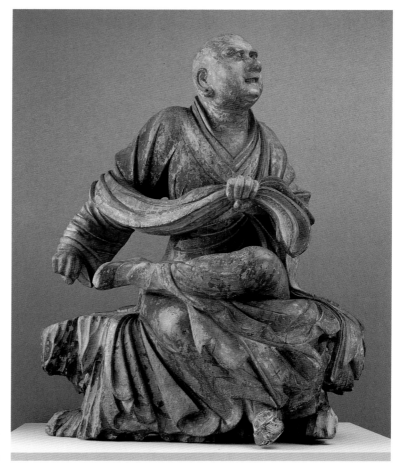

*Arhat (Buddhist
monk)*, Chinese, ca.
14th century, late
Yuan–early Ming
period (1280–1638),
wood with poly-
chrome, 41×30×22 in.

OLYMPIC SCULPTURE PARK

The opening of the Olympic Sculpture Park in the fall of 2006 represents a new vision for the museum and for the city. Located in the urban Belltown neighborhood, the park is an eight-and-a-half-acre site that transforms downtown Seattle's largest undeveloped waterfront property from a former industrial site into a vibrant green space that is free to the public. As SAM's third venue, this new park gives visitors the opportunity to experience art in an outdoor setting while enjoying the incredible views and beauty of the Olympic Mountains and Puget Sound.

Weiss/Manfredi Architects of New York created an award-winning design uniting three separate parcels of land divided by Elliott Avenue

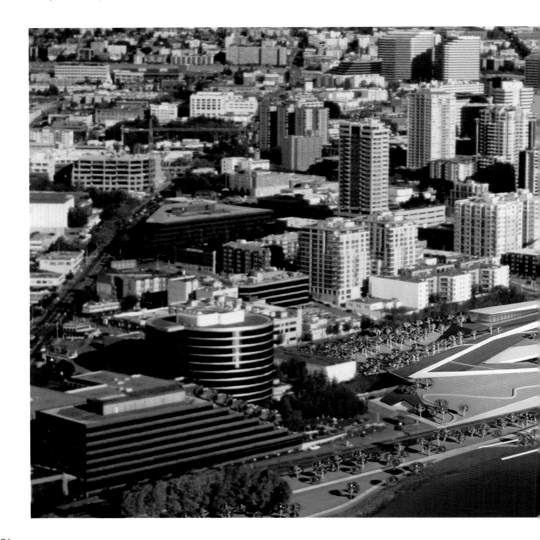

and the Burlington Northern Santa Fe Railroad tracks. The park's precincts are filled with Northwest native plants and trees, laid out in a series of gardens and open meadows that provide a multitextured landscape for art. The works of art sited throughout the park, beginning at the entrance to the Pavilion, a flexible public event space and café, all the way down the Z-shaped promenade to the waterfront pocket beach, reflect a range of approaches to sculpture and, in many cases, a redefinition of the relationship between art and nature.

Conceptual drawing of the Olympic Sculpture Park, 2006

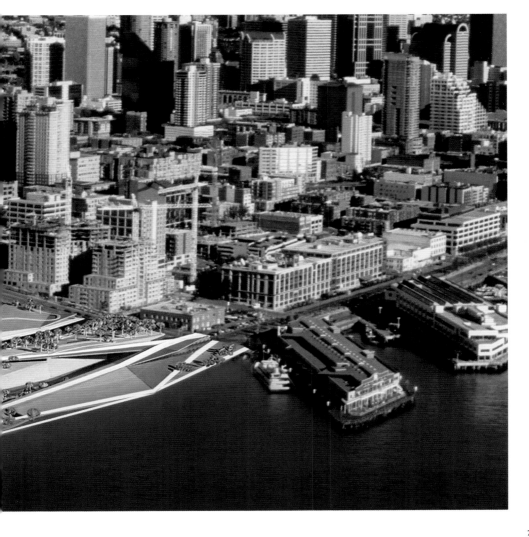

MEN OF STEEL

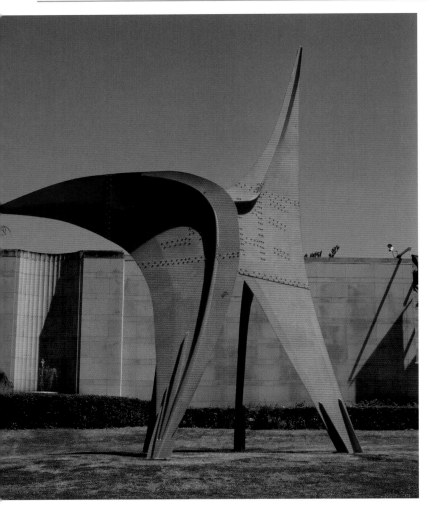

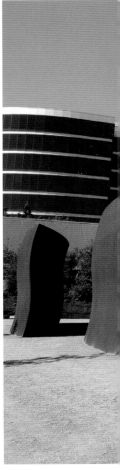

Eagle, 1971,
Alexander Calder,
American, 1898–
1976, painted steel,
overall: 38 ft. 9 in. ×
32 ft. 6 in. × 32 ft. 6 in.

Created when Alexander Calder was already recognized as one of the world's greatest sculptors, *Eagle* reveals the pragmatism and poetry that shaped his work for more than fifty years. A third generation American sculptor, Calder studied mechanical engineering before studying art. A 1926 visit to Paris alerted him to developments in international modern art that proved to be of lasting influence. He was especially drawn to the elemental abstraction and colors of Piet Mondrian's painting and to the sinuous lines and playful characters in the work of Juan Miró. His stationary sculptures, or stabiles, were first produced in Paris in the 1930s; at the time he made *Eagle* he was entirely devoted to this form, which he used for monumental outdoor sculptures sited around the world. *Eagle*'s curving wings and assertive

Wake, 2004,
Richard Serra,
American, born
1939, 10 weather-
proof steel plates
(5 sets of 2),
overall installation:
14 × 125 × 46 ft.

stance assume a playful attitude in the guise of industrial materials, scale, and structure remade as a colorful abstract form.

For Richard Serra space is a substance as tangible as sculpture—an artistic medium that for this artist involves a deliberate treatment of materials and scale to alter perception. Comprised of five identical modules, each with two S-shaped sections positioned in inverted relation to one another, *Wake*'s gently curving serpentines of convex and concave parts suggest tidal waves or profiles of battleships. Its surface of acid-washed, weatherproof steel reinforces the industrial effect. The configuration of the sculpture cannot be known all at once by viewers, but only experienced through time, by moving through it and round it. The artist achieved the towering, curved steel forms of *Wake* using computer imaging and machines that manufacture ship hulls, including a de-militarized version that produced French nuclear submarines.

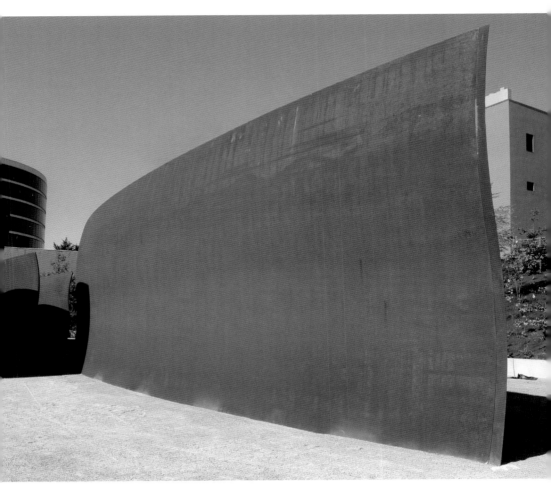

IN THE BALANCE

Mark di Suvero first attracted recognition in the 1960s for his transformation of found elements such as wood and metal into sculptural compositions of massive I-beams crisscrossing in space. Motion, a leitmotif in his early work, became the basis for di Suvero's "balance pieces" of the 1970s, in which welded steel elements turn on narrow pivot points. A descendant of these works, and indebted to the kinetic sculpture of Alexander

Schubert Sonata,
1992, Mark di Suvero,
American, born
1933, painted and
unpainted steel,
22 ft. h., 10 ft. diameter top element,
6 ft. diameter base

Stinger, 1967–68/1999, Tony Smith, American, 1911–1980, steel, painted black; 6½ × 33.4¼ × 33.4¼ ft.

Calder, *Schubert Sonata* is one of many sculptures by the artist named for composers. Its powerful circular composition of organic shapes possesses an urban and industrial flavor, and openness to the sky that lends *Schubert Sonata* its elegant visual rhythm.

One of the most important American sculptors of the postwar period, Tony Smith began his career as an architect, realizing his first steel sculpture in 1962. Developing his ideas in the early 1950s, Smith shared with close friends, painters Jackson Pollock and Barnett Newman, an interest in the art, collective myths, and archetypes of early cultures. The exploration of scale in sculpture, a matter of both size and perception, became a significant medium for Smith's ideas. *Stinger* is a thirty-two-foot square free-standing object, balancing on a single diamond point. Though imposing in scale, the sculpture's structure beckons the viewer to approach its interior, by passing its one open side. Sketches show Smith was thinking of ancient gates when he made this sculpture, but he titled it after the popular cocktail that slyly masks its potent effects with sweetness.

CREDITS